DOVE O'KEEFFE

circles of influence

debra bricker balken

STERLING AND FRANCINE CLARK ART INSTITUTE

WILLIAMSTOWN, MASSACHUSETTS

DISTRIBUTED BY YALE UNIVERSITY PRESS

NEW HAVEN AND LONDON

This book is published on the occasion of the exhibition
Dove/O'Keeffe: Circles of Influence

Sterling and Francine Clark Art Institute
Williamstown, Massachusetts
7 June–7 September 2009

Dove/O'Keeffe: Circles of Influence was organized by the
Sterling and Francine Clark Art Institute.

 The exhibition is supported in part
by a grant from the National Endowment
for the Arts and by an indemnity
from the Federal Council on the Arts
and the Humanities.

Cover illustrations:
Front, (top) Georgia O'Keeffe, *Sunrise,* 1916 (plate 17);
(bottom) Arthur Dove, *Sunrise #1,* 1936 (plate 18)
Back, (top) Alfred Stieglitz, *Georgia O'Keeffe,* 1923 (fig. 73);
(bottom) Alfred Stieglitz, *Arthur G. Dove,* 1923 (fig. 72)

Distributed by Yale University Press
New Haven and London
www.yalebooks.com

Printed and bound in Italy
10 9 8 7 6 5 4 3 2 1

Produced by the Publications Department of the
Sterling and Francine Clark Art Institute,
225 South Street, Williamstown, Massachusetts
www.clarkart.edu

Curtis R. Scott, Director of Publications
Katherine Pasco Frisina, Production Editor
Teresa E. O'Toole, Publications and Curatorial Intern

Copyedited by Ellen R. Feldman
Designed by Susan Marsh
Type composed in DIN and Neutraface Display
by Matt Mayerchak
Index by Kathleen M. Friello
Color separations and printing by Trifolio S.R.L., Verona
Printed on 135 gsm Gardapat Kiara

Library of Congress Cataloging-in-Publication Data
Balken, Debra Bricker.
 Dove/O'Keeffe : circles of influence / Debra Bricker
Balken.
 p. cm.
 Published on the occasion of an exhibition held at the
Sterling and Francine Clark Art Institute, Williamstown,
Mass., June 7–Sept. 7, 2009.
 Includes bibliographical references and index.
 ISBN 978-0-931102-82-0 ((Clark) : alk. paper)
 ISBN 978-0-300-13410-0 ((Yale) : alk. paper)
1. O'Keeffe, Georgia, 1887–1986 — Exhibitions.
2. O'Keeffe, Georgia, 1887–1986 — Friends and
associates — Exhibitions. 3. Dove, Arthur Garfield,
1880–1946 — Exhibitions. 4. Dove, Arthur Garfield,
1880–1946 — Friends and associates — Exhibitions.
5. Modernism (Art) — United States — Exhibitions.
I. Sterling and Francine Clark Art Institute. II. Title.
N6537.O39A4 2009b
759.13 — dc22
 2009003345

Contents

Lenders to the Exhibition

Addison Gallery of American Art, Phillips Academy, Andover, Massachusetts

Peter and Kirsten Bedford

Colorado Springs Fine Arts Center

Columbus Museum of Art, Ohio

Corcoran Gallery of Art, Washington, D.C.

Curtis Galleries, Minneapolis

Des Moines Art Center, Iowa

The Estate of Arthur Dove

Barney A. Ebsworth

Fine Arts Museums of San Francisco

Georgia O'Keeffe Museum, Santa Fe, New Mexico

Herbert F. Johnson Museum of Art, Cornell University, Ithaca, New York

Pitt and Barbara Hyde

Ellsworth Kelly

William H. and Saundra B. Lane Collection

The Metropolitan Museum of Art, New York

Milwaukee Art Museum

The Minneapolis Institute of Arts

The Museum of Modern Art, New York

National Gallery of Art, Washington, D.C.

National Gallery of Canada, Ottawa

Newark Museum

Norton Museum of Art, West Palm Beach, Florida

Philadelphia Museum of Art

Saint Louis Art Museum

Michael and Fiona Scharf

Deborah and Ed Shein

The Shey Collection

Carmen Thyssen-Bornemisza Collection

Wadsworth Atheneum Museum of Art, Hartford, Connecticut

Whitney Museum of American Art, New York

Williams College Museum of Art, Williamstown, Massachusetts

Private collections

Special thanks to the following galleries and museums for their assistance with loans from private collections: Alexandre Gallery, New York; Harn Museum, Gainesville, Florida; Museum of Fine Arts, Boston; and Thyssen-Bornemisza Museum, Madrid

Foreword

There is no question that Georgia O'Keeffe, America's pioneering modernist painter, resides at the forefront of the public imagination. Her haunting, radiant paintings of skulls, flowers, and the American southwest captivate audiences no less than the details of her long, productive life. *Dove/O'Keeffe: Circles of Influence* presents a fresh perspective on O'Keeffe, examining a previously unexplored aspect of her artistic development: her longtime respect for the abstract painter Arthur Dove and the manner in which his work helped shape the development of her art.

This visual chapter in O'Keeffe's story begins in the 1910s in New York, at the moment of her emergence on the art scene and her introduction to Dove and his dynamic pastels. Inspired by his example, O'Keeffe experimented with color and medium, while her work, in turn, led Dove into new areas of formal innovation. Their artistic dialogue yielded a modernism based on direct, emotional responses to the rhythms and splendors of nature. In this regard, *Dove/O'Keeffe: Circles of Influence* is especially fitting as the Clark's first foray into twentieth-century art. The exhibition and its catalogue by guest curator Debra Bricker Balken present a compelling look at a relatively unexplored aspect of an artist's career, and the boldly abstracted works of Dove and O'Keeffe — inspired by the natural settings of the Adirondacks, Long Island, and beyond — harmonize with the beauty of our pastoral campus.

I thank Debra for her enthusiastic dedication to this project; her expertise and collegiality have helped navigate the exhibition through every stage of its development. The entire Clark staff has worked to bring this exhibition to fruition, with the hope that it presents its story in an engaging manner that encourages future scholarship. Of course, realizing such ambitions relied heavily on the generous support of the exhibition's many lenders. We thank these public institutions and private collectors for their invaluable participation, noting in particular the considerable assistance provided by Ann and Andrew Dintenfass on behalf of the Dove estate. Director George G. King and Curator Barbara Buhler Lynes of the Georgia O'Keeffe Museum in Santa Fe were essential supporters of both the exhibition and this catalogue, and we are grateful for their substantial efforts on the Clark's behalf. The Clark also extends special thanks to the National Endowment for the Arts and the Federal Council on the Arts and Humanities, whose generous support made this vibrant exhibition possible.

Michael Conforti
Director, Sterling and Francine Clark Art Institute

Acknowledgments

This exhibition had its origins in a conversation. In the spring of 2005, I had the good fortune to serve as the Robert Sterling Clark Visiting Professor in the Williams College Graduate Program in the History of Art. While in Williamstown for the term, Richard Rand, senior curator at the Clark, and I began to discuss the possibility of mounting an exhibition that would pair the work of Arthur Dove and Georgia O'Keeffe. I had long been intrigued both by the formal correspondences that frequently obtained between these two artists' work as well as by the critical reception that resulted in their metaphoric coupling during the 1920s, when American modernists associated with the circle of Alfred Stieglitz gained increased visibility. The numerous reviewers who paired the painting of Dove and O'Keeffe often used new Freudian discourses to mine their work for its masculine and feminine connotations. The provocations of these sexualized readings helped to situate Dove and O'Keeffe at the forefront of the American avant-garde, distinguishing their work from foreign — specifically French — modes of invention. Both artists had little truck with the aesthetics of Cubism; they deemed the Cubist project too narrowly confined to the elaboration of compositional form, unable to address the sensual dimensions of nature and its corporeal equivalents. And while Dove was momentarily drawn to the formalist theories of Guillaume Apollinaire, one of the principal architects of Cubism, he, like O'Keeffe, would never give up on the landscape, its ephemeral and mutable dimensions an ongoing source of visual tropes and themes.

I am very pleased that my discussions with Richard became formalized as an exhibition, and I thank him for his interest and initiative, especially since *Dove/O'Keeffe: Circles of Influence* is the Clark's first major project devoted exclusively to a twentieth-century subject. Once my idea was adopted, my interactions with the Clark extended to a full range of staff members, all of whom made significant contributions to the realization of this show. I am grateful to Kathleen Morris, director of exhibitions and collections, for her deft oversight of the administration of the project, particularly her handling of the myriad details and logistics that attended its realization. My research for this show was initially assisted by Aimee Hirz, a former curatorial assistant at the Clark. Aimee responded with good humor and alacrity to my constant requests for articles and visual materials, in addition to coordinating the loans for the exhibition. She was succeeded by Sarah Hammond, who brought similar organizational skills to *Dove/O'Keeffe: Circles of Influence* and adeptly oversaw the final stages of the checklist and ephemera for the show. Both

Aimee and Sarah worked with Clark reference librarian Karen Bucky, who, together with her staff, tracked and located the sometimes obscure references that appear in the notes to my essay.

It has been a pleasure to work with Curtis Scott, director of publications, as well as with Katie Frisina, production editor, and Teresa O'Toole, publications and curatorial intern. I am very appreciative of their ongoing patience as well as their assiduous attention to my text and its accompanying images. In addition, Ellen R. Feldman, copy editor, sensitively improved upon its major components. The challenging task of orchestrating the loans for this exhibition fell to Mattie Kelley, director of collections management and senior registrar. The installation of the exhibition was expertly handled by Paul Dion, Harry Blake, and Tom Merrill. In addition, Susan Marsh was responsible for the elegant design of this publication and Diane Gottardi conceptualized the plan for the inventive installation.

I am also indebted to the generosity of the numerous lenders who parted with their works for this show, and I extend my deep gratitude to all of them. I would like to highlight, in particular, the extraordinary efforts of the following individuals: Barbara Buhler Lynes at the Georgia O'Keeffe Museum, Santa Fe; Graham Larkin and Anabelle Kienle at the National Gallery of Canada, Ottawa; Michael R. Taylor at the Philadelphia Museum of Art; Harry Cooper at the National Gallery of Art, Washington; Philippe Alexandre of the Alexandre Gallery, New York; Martha Parrish and James Reinish of Parrish & Reinish, Inc.; Toni Dove; and Andrew and Ann Dintenfass.

During the course of mounting *Dove/O'Keeffe: Circles of Influence* I have relied upon the wisdom and insight of many friends and colleagues. I would especially like to acknowledge my ongoing exchanges with Richard Kendall and Marc Simpson at the Clark. In addition, I have valued the input of Michael Ann Holly and Mark Ledbury of the Clark's Research and Academic Program. Deborah Rothschild has been not only a gracious hostess on my numerous trips to Williamstown but a warmhearted source of support.

Other individuals who have made major contributions include Barbara Lampron, who coordinated the many meetings that attended this show; Maureen Hart Hennessey, who was responsible for obtaining its funding; as well as Lisa Green, Sally Morse Majewski, and Sarah Hoffman, who have worked to secure publicity.

Lastly, I extend my appreciation to the Clark's director, Michael Conforti, for his faith in *Dove/O'Keeffe: Circles of Influence*. I am honored to have produced the first modernist exhibition for an institution that continues to make a substantial, dynamic commitment to both scholarship and public education.

Debra Bricker Balken

Chronology

1880 Arthur Dove is born in Canandaigua, New York.

1887 Georgia O'Keeffe is born near Sun Prairie, Wisconsin.

1905 The photographer Alfred Stieglitz (1864–1946) opens the Little Galleries of the Photo-Secession at 291 Fifth Avenue in New York. Soon known simply as "291," the gallery is the first venue for modern art in the United States. Stieglitz exhibits the work of Paul Cézanne, Auguste Rodin, and Pablo Picasso, in addition to American artists such as Marsden Hartley, John Marin, and Paul Strand.

1907 O'Keeffe enrolls at the Art Students League of New York, where she studies with William Merritt Chase and Kenyon Cox, among others. She leaves the program after one year to work in Chicago as a freelance commercial artist, then moves to Charlottesville, Virginia.

1908 Dove, who had worked successfully as an illustrator in New York after studying both law and studio art at Cornell University, spends a year in France to pursue a career as a fine artist.

1909 Dove returns to New York, where he meets Alfred Stieglitz.

1910 Stieglitz exhibits works by Dove in a group show at 291.

Dove moves to Westport, Connecticut, where he lives for the next eleven years, supporting himself as a farmer and illustrator. While his output as an artist diminishes, he becomes associated with the writers Sherwood Anderson, Paul Rosenfeld, and Van Wyck Brooks, who will become involved in defining the originality and singularity of American modernism.

1910–17 O'Keeffe holds a variety of teaching jobs in Virginia, Texas, and South Carolina.

1912 Dove's first and only solo exhibition is held at 291. The show, which travels to the Thurber Galleries in Chicago, establishes Dove as the first artist to produce an abstract painting in the United States.

1913 The International Exhibition of Modern Art, known as the Armory Show, opens in New York before traveling to Chicago and Boston. It is the first major showcase for international modern art in the United States. Dove chooses not to participate in the event.

1914 Arthur Jerome Eddy publishes *Cubists and Post-Impressionism*, the first survey of modern art by an American writer. O'Keeffe, drawn to a reproduction of a Dove pastel in the book, begins to track his work.

Outbreak of World War I.

O'Keeffe enrolls for one year at Teachers College, Columbia University.

1916	*The Forum Exhibition of Modern American Painters* is launched at the Anderson Galleries in New York, where O'Keeffe sees Dove's pastels in person for the first time.
	Stieglitz includes O'Keeffe in a group exhibition at 291.
1917	O'Keeffe exhibits paintings and watercolors at 291 in the last show at the gallery, which closes due to lack of finances.
1918	Stieglitz and O'Keeffe become romantically involved, and O'Keeffe moves to New York permanently. Within a few weeks, she is introduced to Dove.
1920	Dove leaves his family in Westport to live with the artist Helen Torr. He resumes painting on a regular basis.
	Paul Rosenfeld publishes "American Painting" in the *Dial*, in which he pairs Dove and O'Keeffe in a metaphoric coupling, claiming Dove to be "ever the man in painting and O'Keeffe ever the woman."
1924	Rosenfeld publishes *Port of New York*, a series of essays on figures such as Dove, Marin, Hartley, Stieglitz, and O'Keeffe, in which he perpetuates his Freudian analysis, elaborating on the correspondences between the work of Dove and that of O'Keeffe.
	O'Keeffe and Stieglitz marry.
1925	Stieglitz assembles *Seven Americans*, an exhibition at the Anderson Galleries that draws on the work of Charles Demuth, Dove, Hartley, Marin, O'Keeffe, Strand, and himself. The exhibition aims to consolidate the individuality and authenticity of American art. The linkages between the work of Dove and that of O'Keeffe are elaborated upon by numerous subsequent writers.
	Stieglitz opens the Intimate Gallery.
1929	The Intimate Gallery closes and Stieglitz opens An American Place, his third and last gallery.
	O'Keeffe begins to divide her time between New York and Abiquiu, New Mexico.
	New York Stock Exchange collapses.
1930	Dove commences work in watercolor, recalling, as he put it, the "burning watercolors" that O'Keeffe exhibited at 291 in 1917.
	Throughout her later life, O'Keeffe continues to cite Dove as the major influence on her work.
1946	Stieglitz dies in New York in July; Dove dies on Long Island in late November.
1949	O'Keeffe leaves New York to live permanently in New Mexico.
1986	O'Keeffe dies in Santa Fe, New Mexico.

Works by Arthur Dove and Georgia O'Keeffe are fully documented in their catalogues raisonnés, listed below. Additional information on Dove's paintings and selected works on paper is provided in the 1997 *Retrospective*.

Abbreviations are as follows:

ALM Ann Lee Morgan, *Arthur Dove: Life and Work, a Catalogue Raisonné* (Newark: University of Delaware Press, 1984)

BBL Barbara Buhler Lynes, *Georgia O'Keeffe: Catalogue Raisonné*, 2 vols. (New Haven, Conn.: Yale University Press; Washington, D.C.: National Gallery of Art; Abiquiu, N. Mex.: The Georgia O'Keeffe Foundation, 1999)

DBB Debra Bricker Balken, *Arthur Dove: Retrospective* (Andover, Mass.: Addison Gallery of American Art; Cambridge, Mass.: MIT Press, in association with the Phillips Collection, Washington, D.C., 1997)

Cross-references to these sources are provided in the captions. Titles, dates, and media are informed by these sources unless otherwise noted. Dimensions were supplied by the owners of the works.

Please note that dates including a slash (/) indicate that the works were completed in *either* one year or the other. Works produced over a range of years are linked by a dash (–).

Original spelling and punctuation have been preserved in quotations from all correspondence and published works. The designation [*sic*] has been added only in those instances where confusion might otherwise result.

DOVEO'KEEFFE

Nature is not so much her own ever-sweet interpreter,

as the mere supplier of that cunning alphabet,

whereby selecting and combining as he pleases,

each man reads his own peculiar lesson

according to his peculiar mind and mood.

HERMAN MELVILLE

I got the sun in the morning and the moon at night.

IRVING BERLIN

Where did I see him? A reproduction in a book. The Eddy book.

In the early 1960s, long after Georgia O'Keeffe (1887–1986) had been established as an American icon, her painting and lifestyle the subject of national discussion since the 1920s, she noted in an interview with Katharine Kuh, the first curator of modern art at the Art Institute of Chicago, that of all the artists she knew, it was Arthur Dove (1880–1946) who had played a major role in the formation of her work. While O'Keeffe surmised that her audiences might regard "nature" as her primary influence, she tempered any such immediacy in her art, acknowledging that, at least in the early stages of a career, painting was an accumulation of debt. "[T]he way you see nature depends on whatever has influenced your way of seeing," she asserted. "I think it was Arthur Dove who affected my start, who helped me to find something of my own."[1]

O'Keeffe's art education had been almost as peripatetic as her upbringing in the Midwest and in the South. She had enrolled first at the Art Institute of Chicago, then at the Art Students League of New York, and subsequently at the University of Virginia and Columbia University. Her studies were constantly interrupted by the need to work, to fuel her family's diminished economic life.[2] Although each segment of this ruptured training yielded introductions that led to lasting relationships and a stable of sources, O'Keeffe's life at the League, in 1907 and 1908, was the most formidable, as it was there

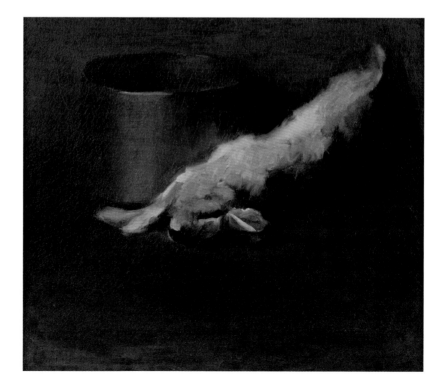

FIG. 2

Edward Steichen (American, born Luxembourg, 1879–1973), *Alfred Stieglitz at 291*, 1915. Coated gum bichromate over platinum print, 11⁵⁄₁₆ x 9½ in. (28.8 x 24.2 cm). The Metropolitan Museum of Art, New York. Alfred Stieglitz Collection, 1933 (33.43.29)

that William Merritt Chase (1849–1916) was one of her teachers. Chase was an undeniable force, marking her work initially with a dark, somber palette and conventional subjects, such as still-life arrangements that recalled the mid-nineteenth century despite their compositional austerity (fig. 1).[3] O'Keeffe knew, though, that Chase would never make any headway in the modernist era, that his aesthetic provocations were too limited, too squarely situated within the academy; he had never dared to break with his circle of patrons and their prescribed interests, which largely hinged on commissioned portraiture. As O'Keeffe averred in her interview with Kuh, "[I] loved using the rich pigment he admired so much, but I began to wonder whether this method would ever work for me . . . I began to realize that a lot of people had done this same kind of painting before I came along. It had been done and I didn't think I could do it any better."[4]

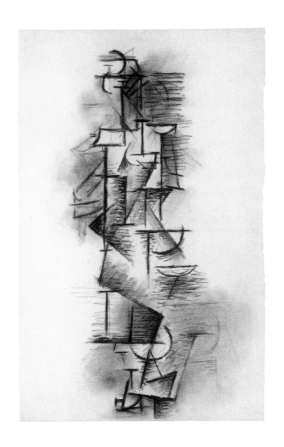

FIG. 3

Pablo Picasso (Spanish, 1881–1973), *Standing Female Nude*, 1910. Charcoal on paper, 19 x 12³⁄₈ in. (48.3 x 31.4 cm). The Metropolitan Museum of Art, New York. Alfred Stieglitz Collection, 1949 (49.70.34)

FIG. 4

Auguste Rodin (French, 1840–1917), *Standing Nude with Draperies*, c. 1900–1905. Watercolor and graphite on paper, 17¹⁄₂ x 12¹⁄₂ in. (44.5 x 31.7 cm). The Art Institute of Chicago. Alfred Stieglitz Collection

But O'Keeffe also had her doubts about Chase's prognostications for the future of art, especially about his investment in the French artist Jean Louis Ernest Meissonier (1815–1891), whose work Chase had purchased in depth. As she retrospectively pointed out to Kuh, Chase had missed out on or spurned the radical dimensions that had reshaped art in the early twentieth century with its brazen revision of form. O'Keeffe had seen a cursory sampling of this progressive, new modernist work at Alfred Stieglitz's Little Galleries of the Photo-Secession in New York, which was known as "291" for its address on Fifth Avenue, while she was a student at the League (fig. 2). It was there, in 1908, that O'Keeffe was introduced to the work of Auguste Rodin (1840–1917), and later she came to know the work of Pablo Picasso (1881–1973; fig. 3), Georges Braque (1882–1963), and Francis Picabia (1879–1953). She took in their audacious reconstitution of the figure, in which anatomy was alternately abbreviated or fractured, with curvature reduced either to a mere silhouette or to a tangled grid of angles and planes. Whatever her reservations about perpetuating Chase's methodology, she initially found the work on the walls at 291 foreign, too caught up in a closed artistic dialogue centering on the reformation of style. These cerebral exercises, which seemed to lack a historic or conceptual framework, were too remote for the young artist. As she said of Rodin's exhibition of works on paper at Stieglitz's showcase (fig. 4), "They made no sense. They were very beautiful but really just a lot of little scribbles to me. This was because of what I was

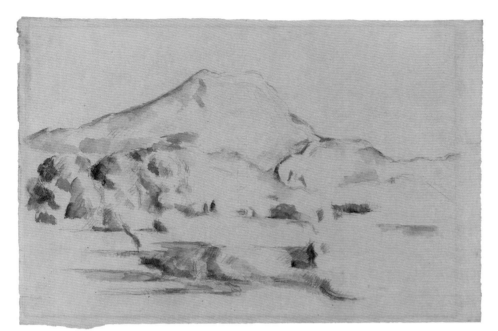

FIG. 5

Paul Cézanne (French, 1839–1906), *Mont Sainte-Victoire*, c. 1890. Watercolor and pencil on paper, 12¹⁵⁄₁₆ x 19⅞ in. (32.8 x 50.5 cm). The Samuel Courtauld Trust, The Courtauld Gallery, London

being taught."[5] Much later, though, she acknowledged, "[W]hen I was settling Stieglitz's estate [in 1946], they were the drawings I most enjoyed."[6] Their sensual features, delicate washes of watercolor, and erotic renditions of the female body clearly would become part of her corpus of references, however unconsciously absorbed at the beginning.

O'Keeffe was overwhelmed and confused by the modernity of Stieglitz's enterprise, especially in light of her classes at the League, which included sessions not only with Chase but with Kenyon Cox (1856–1919), a figure who advocated some display of technical facility as well as the use of the symbol, features that were deemed outworn or regarded as the workings of a retrograde sensibility by the generation of progressive artists who emerged in Paris and New York in the early 1900s.[7] Hence, when O'Keeffe arrived in Manhattan, she was aghast to learn that "everyone wanted to find out what Cézanne was all about," that discussions relating to the "plasticity" of his work — that is, its concrete, structural presence — had spread well beyond the League, where it had become the subject of ridicule and fierce debate.[8] Alfred Stieglitz first introduced prints and watercolors by Paul Cézanne (1839–1906) to American audiences in 1910 and 1911 (fig. 5).[9] Although O'Keeffe did not see these shows, talk about Cézanne's painting had circulated in New York's small art world, largely through those who had seen his work in Paris, occasioning both anticipation and a defensiveness about the native attributes of American art (such was Chase's formidable recasting of Impressionism).

Whatever misgivings O'Keeffe may have had about the contemporary iterations of modernism, she found 291 a congenial rather than a hostile place, one to which she was increasingly lured. In the late spring of 1916,

FIG. 6

Georgia O'Keeffe, *Early No. 2*, 1915. Charcoal on paper, 24 x 18½ in. (61 x 47 cm). The Menil Collection, Houston. Gift of The Georgia O'Keeffe Foundation

BBL 51

FIG. 7

Georgia O'Keeffe, *No. 9 Special*, 1915. Charcoal on paper, 25 x 19⅛ in. (63.5 x 48.6 cm). The Menil Collection, Houston

BBL 54

soon after she met Stieglitz, she wrote to him just after the gallery had closed for the summer, "It's nice to think that the walls of 291 are empty — I went in a year ago after you had stripped them — and I just thought things on them — it is one of the nicest memories I have of 291. That is absurd to say — I often wondered what it is you put into the place that makes it so nice even when its empty — just tracks in the dust on the floor and a chair at a queer angle — still it was great and I was glad that I had gone — glad that I saw no one."[10]

The entrenched narrative that surrounds O'Keeffe's relationship with 291 involved an intermediary, Anita Pollitzer (1894–1975), a classmate from Teachers College at Columbia University, where O'Keeffe had enrolled in the fall of 1914 (wanting eventual professional employment to offset her studio practice). Unbeknownst to O'Keeffe, Pollitzer took a roll of O'Keeffe's charcoal drawings to show to Stieglitz in early 1916 (figs. 6 and 7; see also figs. 11, 19, and 20). Pollitzer sensed that an alliance could be made, that O'Keeffe's abstractions of nature fit the programmatic thrust of the gallery and its defiance of the ongoing reverberations of Impressionist painting in the United States. Stieglitz's response to O'Keeffe's work was instantaneous. It was also sensational in its claims and provocations. As Pollitzer later described the moment to O'Keeffe, he was said to have immediately declared, "Finally, a woman on paper."[11] This, at least, is how the story goes; the moment has been escalated into myth. But the (supposed) utterance did accrue a certain veracity when Stieglitz integrated O'Keeffe's drawings into

a show soon thereafter, again without consulting O'Keeffe. There are various spins on this story, but as Stieglitz straightforwardly recounted in *Camera Work* (the quarterly journal that covered the exhibitions, issues, and artists that pertained to 291 and that supplemented the gallery's aesthetic mandate with tracts by Henri Bergson, Wassily Kandinsky, Friedrich Nietzsche, Gertrude Stein, and others), "It was different from anything that had been shown at '291.' . . . Miss O'Keeffe's drawings . . . were of intense interest from a psycho-analytical point of view. 291 had never before seen [a] woman express herself so frankly on paper."[12]

O'Keeffe was not nearly as "outraged" as some interpreters have claimed by Pollitzer's sub rosa introduction of her work to Stieglitz and his subsequent public orchestration.[13] In fact, she wrote to Pollitzer that she was grateful for the interest, although she was mystified by some of the recognition, pronouncing, "[I]t is so nice to feel that I said something to you — and to Stieglitz. I wondered what I said — I wondered if any of you got what I tried to say — Isn't it damnable that I cant talk to you. If Stieglitz says any more about them — ask him why he liked them. . . . Of course I would rather have something hang in 291 than any place in New York — but wanting things hung is simply wanting your vanity satisfied."[14] At the time that this off-handed transfer of her drawings took place, O'Keeffe was living in Columbia, South Carolina, where she had secured a position teaching art at Columbia College. Her relative isolation there made her feel especially vulnerable and detached from the modernist vitality, however nascent, in New York, hence her request that Pollitzer "ask him [Stieglitz] why he liked them."

During O'Keeffe's time in South Carolina, Pollitzer provided her with a lifeline to New York, ensuring that she received her copies of both *Camera Work* and *291*, a publication launched by the Mexican caricaturist and writer Marius de Zayas (1880–1961) in 1915, so that she retained some currency with the exhibitions and ideas that preoccupied its burgeoning art scene. Their correspondence hinges, in part, on Stieglitz's roster of exhibitions and publications, and on New York's marketplace for art, which had rapidly assimilated the precepts of modernism, as well as the differences that now obtained between 291 and de Zayas's new Modern Gallery, located at 500 Fifth Avenue. Of the latter venture Pollitzer remarked, "[T]hings are bought there — sold rather — and of course at 291 no one ever mentioned money. 291 will still live for the same reason as it always has lived, and this 500 will be an outlet for goods which is good!"[15]

De Zayas worked for the *New York Evening Herald* and had assembled two exhibitions of his own work at 291 while occasionally contributing to *Camera Work* (figs. 8 and 9).[16] He had once conveyed to Stieglitz that he thought Stieglitz had "accomplished more than anybody else in the world of art in

FIG. 8

Alfred Stieglitz (American, 1864–1946), *Marius de Zayas*, 1915. Platinum print, 9⅝ x 7⅝ in. (24.5 x 19.4 cm). National Gallery of Art, Washington, D.C. Alfred Stieglitz Collection

FIG. 9

Marius de Zayas (Mexican, 1880–1961), *Alfred Stieglitz*, c. 1912–13. Photogravure print. From *Camera Work* 46 (Oct. 1914): plate V. Private collection

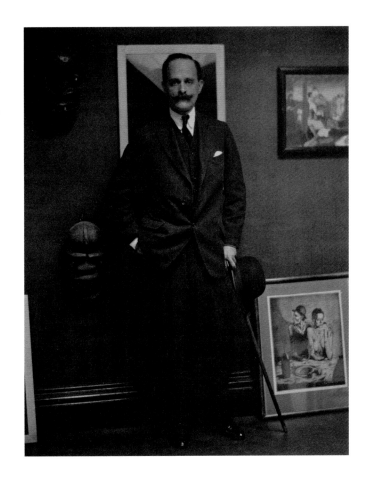

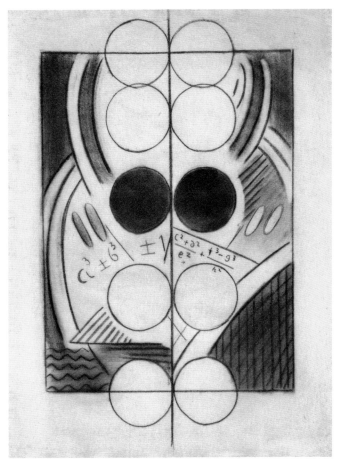

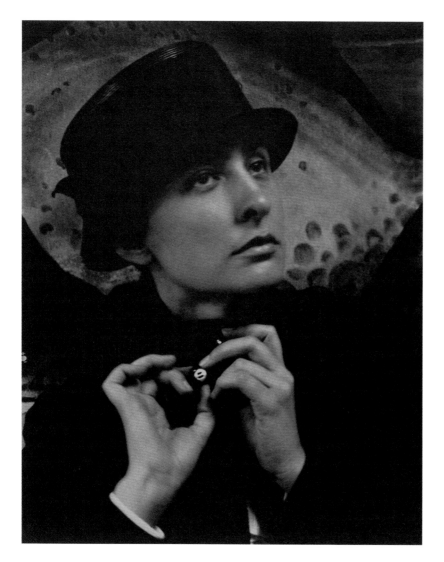

FIG. 10

Alfred Stieglitz, *Georgia O'Keeffe: A Portrait*, 1918. Platinum print, 9^{11}/$_{16}$ x 7^{3}/$_{4}$ in. (24.6 x 19.7 cm). The J. Paul Getty Museum, Los Angeles

America, and . . . that the real thing is just beginning."[17] Despite such adulation, a rift erupted between the two just as O'Keeffe entered Stieglitz's orbit (fig. 10). The issue of sales that Pollitzer had touched upon became divisive, with Stieglitz maintaining that art was an entirely pure endeavor, that its trade or commerce should be confined to discreet backroom discussions, not foregrounded by promotion, let alone by hucksterism. De Zayas might have thought that an opportunity existed to redirect the course of modernism in New York, especially after the sensational press coverage generated by the Armory Show in 1913 (the first international showcase for modern art in the United States, which traveled from New York to Chicago and Boston), but his gallery was ultimately too tied to Stieglitz's paradigm. He showed many of the same artists, particularly such Europeans as Cézanne, Picasso, and Picabia. Despite these similarities, their warfare resulted in de Zayas's outright contempt. He had become convinced that Stieglitz's project was spent: it no longer possessed its earlier risk and originality. In his new venture as a dealer — a role that he shared with his partners Paul B. Haviland, a painter,

photographer, and associate editor of *Camera Work,* and Agnes Ernst Meyer, a collector — de Zayas aimed for a more direct relationship between producer and consumer.[18] He patently dismissed the sanctity of the creative process and its elusive unfolding within the private confines of the artist's studio.

De Zayas had clearly harbored a certain frustration with Stieglitz's business style, eventually noting that manifold contradictions obtained between Stieglitz's operations and his aesthetic outlook. De Zayas thought that some reconciliation was required if New York was to have a stake in the marketplace and in the heady new discourses on advanced art. These prospects would remain inseparable. In his view, critical interpretation needed to play an integral role in the packaging of vanguard art, determining its direction and becoming an aid to commerce. "Stieglitz knew how to sell, when, and to whom," de Zayas conceded. "But the cases were rare and exceptions to the rule. That non-commercial, refined attitude helped also to inspire respect for modern art. It was shown for its merits and not for its value in dollars."[19] As the wrangling between de Zayas and Stieglitz escalated, the latter's privileging of art over business was increasingly construed as a failing. In fact, de Zayas compounded the flaws in his erstwhile mentor's program by making numerous acerbic declarations.[20] He even declared, soon after opening the Modern Gallery in 1915, "[T]he inhabitants of the artistic world in America are coldblooded animals. They live in an imaginary and hybrid atmosphere. They have the mentality of homosexuals. They are flowers of artificial breeding."[21] These references were loaded with the all-too-prevalent charges that the New York avant-garde had become unnecessarily dependent on European sources. But they were also overlaid with de Zayas's machismo, a feature that saturated much of the critical writing on art of this period, albeit with less vitriol and sarcasm. His rhetoric might have been aggressive and hard-hitting, yet it was meant to embolden a small circle of modernists whom he sensed could position New York as an international center for art through a more vigorous declaration of the city's — and hence American — singularity.

The same year that de Zayas levied his charges, Marcel Duchamp (1887–1968) landed in New York, hoping to evade both the war in Europe and the draft in his native France. Soon after his arrival, he declared that the "art of Europe is finished — dead."[22] This was an affirmation to de Zayas and others that New York City was poised to become a cultural leader, able to contend with, or at least to offset, the mecca of Paris. Yet Stieglitz, in de Zayas's estimation, no longer had a stake in this future: his demise as a force in the art world was evident not only because of his cavalier relationship to sales but because of the symbolic meanings that he projected on his artists' work. As his ridicule of Stieglitz began to mount, de Zayas averred

of his former friend, "[I]n pursuing his object, he employed the shield of psychology and metaphysics. He has failed . . . in order to create life — no shields!"[23] If modernism was to gain a foothold in the United States, thought de Zayas, a more rational explanation of painting would be required, one that would concentrate on its "plastic" constituents.

De Zayas and Haviland had earlier attempted such an explication in their collaborative tract *A Study of the Modern Evolution of Plastic Expression*, which, ironically, was published under the auspices of Stieglitz and 291 and timed to appear during the installation of the Armory Show in New York in 1913. Their "study" had a dual mission: to foreground Stieglitz's prescience as a dealer long before the event at the Armory and to serve as an aid for a stupefied American audience whose grasp of art remained largely confined to known representations, that is, to the academic conventions of landscape and portrait painting that artists such as Chase still popularized and perpetuated. Yet, despite the egalitarian aims of their treatise and its goal of reaching an uninformed, bewildered public that had treated the work at 291 as something of a joke or hoax, their study was decidedly polemical, having considerable implications for the interpretation of American modernism in the early twentieth century. Moreover, with its limited edition of one thousand copies and its at times obfuscating language, the tract hardly galvanized a hostile American public. Its readership remained limited to a small, erudite sector, primarily to the converted and predisposed, such as Stieglitz.

De Zayas and Haviland argued that "it can not be reasonably expected of the public that they should understand without some help such a radical departure from established standards in plastic expression."[24] The premise that this "departure" or break with history could be elucidated through an analysis of form, that color and line had ceased to be tethered to narrative subjects in painting, had parallels in the writing of the British art critic Clive Bell (1881–1964), who expounded on the like concept of "significant form" in his book *Art*, published in 1913, seven months after de Zayas and Haviland's thesis.[25] While Bell elaborated more cogently on the independence of the structural rudiments of vanguard art, connecting their centrality to the subjectivity of the painter, his formalist take was neither as evangelizing nor as divisive as that of his American counterparts. The public was never a part of his purview. (Stieglitz acquired a copy of the book soon after it appeared and may have been a conduit in the dissemination of Bell's ideas to his still beholden, enthralled acolytes.)

O'Keeffe continued to resist the "plastic expression" in painting that de Zayas and Haviland touted in their study. Long after she left the Art Students League, she regarded Cézanne as a source of befuddlement. In *A Study of the Modern Evolution of Plastic Expression*, de Zayas and Haviland

had positioned Cézanne as a terminus ad quem, thereby making him the progenitor of the modernist movement. Even as O'Keeffe began to distance herself from Chase, she did not give greater priority to "material form."[26] The inventive goals of modernism rarely overrode or subsumed her subjects. Yet as she became engaged in the growing discourses on modernism around 1914, de Zayas factored into her thinking, providing a partial explanation for her increased abstraction of nature as well as a basis for her teaching. Independent of Haviland, de Zayas had written two essays for *Camera Work* touching on this leitmotif of form. In "The Evolution of Form, Introduction," published on the eve of the Armory Show, he asserted that verisimilitude no longer had any function in art, that the contemporary artist "had to abandon the complex study of realistic form, to which he had limited himself for so many centuries, and turn to the imaginative and fantastic expressions of Form in order to have a complete understanding of the possibilities of its expression."[27] Shortly before, he had identified the "unconscious" as the site or wellspring of this new imagery.[28] Whatever value de Zayas later placed on the "structures" of art and their new modernist autonomy,[29] O'Keeffe was less immersed in theories that related to the codification of form than she was in their generation or agency, drawn instead to de Zayas's emphasis on the intuitive release or unfolding of form, with all of its ambiguity and romance.

O'Keeffe's reading on modernism was incremental and gradual, yet also honed and selective, in large part determined by the writers who had appeared in *Camera Work* and had become part of Stieglitz's circle. Stieglitz had been wounded by de Zayas's public malignments and subversive gestures, put off both by his latter-day mercantilism and his bravado.[30] However, de Zayas's insistence on grappling with the "plasticity" of contemporary art appealed to his intellectual curiosity and helped to shape his own aesthetic credo. (For all of de Zayas's arrogance, his Modern Gallery lasted just seven years; he was never able to convert his confidence in New York's cultural destiny into sales. Moreover, he later admitted that Stieglitz was a "sage,"[31] reversing their momentary antagonism.) While O'Keeffe was familiar with the tracts that de Zayas had written for *Camera Work* and probably read *A Study of the Modern Evolution of Plastic Expression*,[32] as her relationship with Stieglitz fermented in 1916, settling into permanency by mid-1918, she was drawn into the aesthetic battles that surrounded Stieglitz's 291 Gallery and affected by his increased vulnerability both as a proselytizer for modernism and as a dealer. Many of the issues that had challenged her in the studio in the mid-1910s stemmed from this incendiary rift. How could she reconcile the figure with abstract visual languages? How could she describe the role of the unconscious in the creation of art, a prospect that had engaged not only

de Zayas but many other contributors to *Camera Work*?[33] Or, as de Zayas asked more pointedly in 1915, had Stieglitz's "psychology and metaphysics" become too evasive and outmoded? What were the drawbacks of a psychological model for shaping the discussions of American art?

Stieglitz was not O'Keeffe's sole educator. There were others who added to her understanding of modernism, particularly in its American variations, such as Alon Bemont, a former student of Arthur Wesley Dow at Columbia University, whom she had met at summer school at the University of Virginia in 1912. In fact, Bemont had primed her in advance of her meeting with Stieglitz by introducing her to a few of the theoretical studies on art that were available in the United States. O'Keeffe had initially studied drawing with Bemont in Charlottesville. Later, when she attended Teachers College at Columbia in 1914 and 1915, she worked as his assistant during the summers.[34] There, largely at Bemont's urging, she studied with Dow. Many of O'Keeffe's charcoal drawings (fig. 11; see also figs. 6, 7, 19, and 20) subsequently reveal Dow's influence in their sensuous evocations of an undulating line or an occasional geometric form that dispenses with specific reference to nature or the body (fig. 12). Dow had been averse to the copying of an object or figure, aiming instead for an abstract distillation of its primary traits. O'Keeffe's vague floral shapes, alternately spare or abundantly decorative, departed radically from the representations of Chase. Additionally, through the drawings' avoidance of depth, the transition from an old illusory space had been thoroughly effected, landing O'Keeffe in the territory of modernism.

O'Keeffe fully acknowledged that it was Bemont who "told me things to read. He told me of exhibitions to go and see — sometimes even told me of theater not to miss." Before her return to New York in the fall of 1914, he encouraged her to focus on two volumes that had just been released. "The two books that he told me to get were Jerome Eddy, 'Cubists and Post-Impressionism,' and Kandinsky, 'On the Spiritual in Art,'" she recalled. "He told me to look at the pictures in Eddy's book — that I needn't bother to read it — but that I should read the Kandinsky. I looked at the Eddy very carefully and I read the Kandinsky."[35] Through the heady mix of this reading, Dow's teaching, and the exhibitions that she saw in New York, both at 291 and at the Montross Gallery (which would feature a show by Matisse), O'Keeffe gained a deepened sense of the precepts of the avant-garde and its myriad expressions. In one of the first letters that she sent to Pollitzer soon after leaving Teachers College, she wrote, "When I think of the Picasso violin you speak of [fig. 13] — I wonder how it would look to me now — it was the first thing that I saw at 291 last year too — and I looked at it a long time but couldn't get much — I wonder if I could now."[36] Her musing revealed that this modernist

FIG. 11

Georgia O'Keeffe, *No. 20 — From Music — Special*, 1915. Charcoal on paper, 13½ x 11 in. (34.3 x 27.9 cm). National Gallery of Art, Washington, D.C. Alfred Stieglitz Collection, Gift of The Georgia O'Keeffe Foundation

BBL 53

FIG. 12

Arthur Wesley Dow (American, 1857–1922), *Moonrise*, c. 1898–1905. Color woodcut on paper, 5¼ x 7⅞ in. (13.3 x 20 cm). Terra Foundation for American Art, Chicago. Daniel J. Terra Collection, 1996

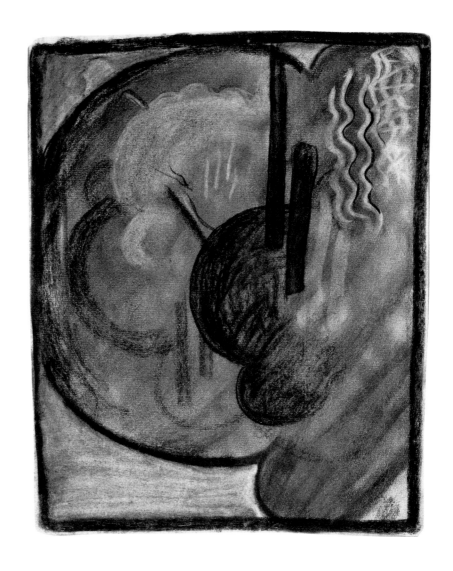

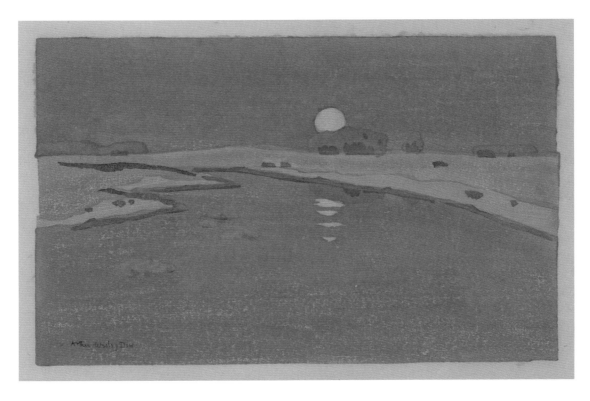

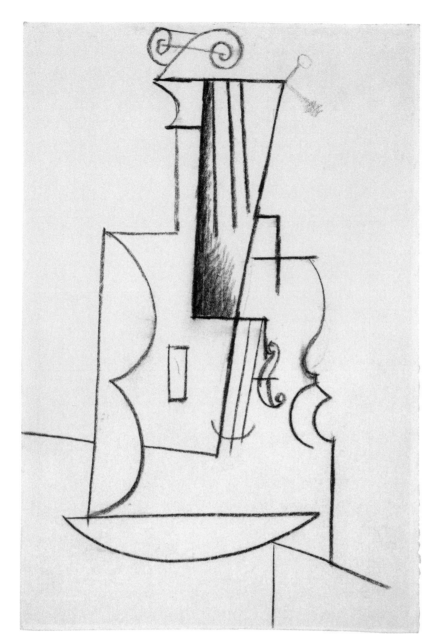

FIG. 13

Pablo Picasso, *Violin*, 1912.
Charcoal on paper, 18¾ x
12¾ in. (47.6 x 32.4 cm).
Philadelphia Museum of Art.
The Louise and Walter
Arensberg Collection, 1950

theory and work was still gestating in her mind, that Bemont's recommendations had become the subject of her intense rumination. The welter of information was still clearly staggering to O'Keeffe, especially since she knew that she needed to articulate her own identity. Her self-definition, after all, was one of the conditions of becoming allied with the vanguard movement. Where could she hang her individuality? How could she best adumbrate its forms and meanings? Much later she averred, "It was sometime before I really began to use the ideas."[37] But her learning curve was not nearly as steep or as prolonged as she claimed. In fact, soon after she left Columbia University, the transformation could be seen first in her charcoal drawings and later in the watercolors that she would exhibit at 291 (see figs. 6, 7, 11, 19, 20, and plates 6 and 49).

It took O'Keeffe more than a year to locate a copy of Kandinsky's *Concerning the Spiritual in Art*.[38] She mentioned to Pollitzer that she was anxious to read the tract and that she had written to the *Masses*, a prominent socialist publication to which she subscribed, to attempt to secure a copy.[39] While the *Masses* had solicited numerous contributions from artists such as Arthur B. Davies (1862–1928), one of the organizers of the Armory Show, its articles and editorials advocated progressive political issues such as women's suffrage and the labor movement, and its relationship to modernism was elliptical at best, as it favored more the realist illustrations of artists affiliated with the Ashcan school, such as John Sloan (1871–1951). O'Keeffe's roundabout inquiry not only failed to yield any information concerning Kandinsky's American publisher but also underscored her still tenuous grip on the New York art world and its diverse preoccupations. In a letter, she petitioned Pollitzer for help in tracking the book. Her digressions in the same letter revealingly — and unwittingly — paralleled the thrust of Kandinsky's argument. In one telling passage, for example, she effused on the correlations between art and music, noting, "You asked me about music — I like it better than anything in the world — Color gives me the same thrill once in a long long time — I can almost remember and count the times — it is usually just the outdoors or the flowers — or a person — sometimes a story — or something that will call a picture to my mind — will affect me like music."[40]

O'Keeffe was unaware of the extract from Kandinsky's essay that had appeared in *Camera Work* in 1912.[41] However, once she found the American translation of *Concerning the Spiritual in Art*, the linkages with her own nascent stance on the origins, development, and function of art became palpable and clear to her. (Even if O'Keeffe did not realize it at the time, Dow surely had elicited these intuitive responses in her course at Columbia, where he had drawn on the parallels between music and painting.)[42] Beyond her discovery that Kandinsky had emboldened form as a conveyor of "inner meaning," there were direct textual correspondences with the realizations that she had voiced in her letter to Pollitzer. Specifically, Kandinsky also focused on the role of color in art, regarding its "sound" as an elusive extension of the artist's subjectivity.[43] The overall composition of a painting might be the equivalent of music, but color, in Kandinsky's view, was the "keyboard" and accounted for its "contrapuntal possibilities."[44] Once O'Keeffe waded through these connections, she was no doubt heartened to learn that Kandinsky had concluded: "Everything is at first a matter of feeling. Even though the general structure may be formulated theoretically, there is still an additional something which constitutes the soul of creation. Any theoretical scheme will be lacking in the essential of creation — the internal desire for expression — which cannot be formulated."[45]

However long it took for O'Keeffe to become conversant with Kandinsky's analogies between art and music, she would have been familiar with the general outlines of his aesthetic platform and work through *Cubists and Post-Impressionism*, a book by Arthur Jerome Eddy (fig. 14) that included four illustrations of his paintings (two in color!). In addition, she would have acquired some sense of Eddy's idiosyncratic evaluations and stabs at categorization that dispensed with style or formal typologies. Bemont had suggested that she focus on the plates in Eddy's publication and dispense with his analysis, an acknowledgment of his own disdain for the study, or at least uncertainty as to its worth. However, as she later revealed to Pollitzer, Eddy's volume was one of the sources that molded her burgeoning modernist views, revealing that she did not find his assessments and structure off base at all. As a teacher at West Texas State Normal College in Canyon in the fall of 1916, one of her three teaching stints before she took up with Stieglitz, she engaged his ideas as part of a required address to the faculty. The occasion forced O'Keeffe to reconcile the myriad materials that Bemont, and later Stieglitz, had recommended that she consider. Not only did she draw connections between the few theoretical texts at her disposal, finding more congruity than divergence among the authors' positions, but they also soon became fixtures in her studio practice. These authorities bolstered, contoured, and directed her instincts. In later years she even met a few of them.

The lecture that O'Keeffe gave in Canyon had weighed upon her for months. Immediately afterward, she wrote to Pollitzer, "I had to give a talk at the Faculty Circle last Monday night. . . . So I had been laboring on Aesthetics — Wright — Bell — De Zayas — Eddy — All I could find — everywhere — have been slaving on it since in November."[46] This string of references once again highlighted the combined influence of Bemont and Stieglitz. Stieglitz, for example, had sent her a copy of Clive Bell's *Art*, the disquisition on "significant form" that would offset de Zayas and Haviland's essay on "plasticity." There she found an entire chapter on "the debt to Cézanne," the figure who had stupefied her when she saw his work while at the Art Students League. Bell construed his apotheosis as the outcome of a legible historical continuum: Cézanne was the heir apparent of modernism, the figure who had sidestepped the amorphous features of Impressionism and re-endowed painting with a solid, identifiable compositional structure. O'Keeffe might still have balked at this aggrandizement, contending there were other epicenters in art, but Bell's insistence that "the particular methods of creating form, and the particular kinds of form affected by the artists of one generation, have an important bearing on the art of the next" added to her understanding that the discussion of "aesthetics" centered increasingly on matters of form.[47]

O'Keeffe's reference to Willard Huntington Wright in her letter to

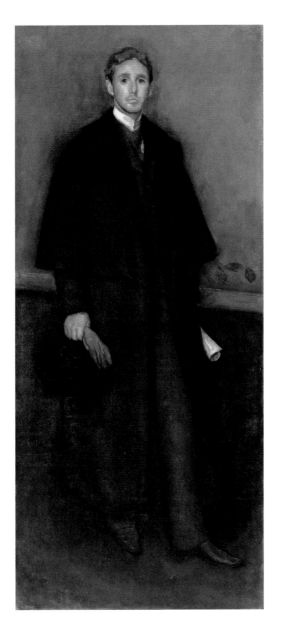

Pollitzer was equally telling. Not only had Wright been the editor of the *Smart Set* before H. L. Mencken and George Jean Nathan jointly assumed the position in 1914, but he was also an avid proponent of the avant-garde. In 1916 he became the organizer of the *Forum Exhibition of Modern American Painters,* in addition to writing for *Studio International* and the *Forum,* the publication from which the show took its name. Stieglitz, too, served on the committee for the *Forum Exhibition,* as well as wrote the foreword to the accompanying catalogue. He may even have encouraged O'Keeffe to read Wright's seminal essay "What Is Modern Painting?" — included in the catalogue — which distilled the primary tenets from his earlier book, *Modern Painting: Its Tendency and Meaning.* There Wright argued, much like de Zayas and Bell, that "modern art is the logical and natural outgrowth of ancient art; it is the art of yesterday heightened and intensified as the result

of systematic and painstaking experimentation in the media of expression."[48] Wright, too, constructed a formalist trajectory for art, one that was linear in its extensions, that was knit together by an ongoing commitment to the redefinition of form. While Cézanne occupied a paramount position in his thesis as well, Kandinsky was ranked "among the decadents" for evoking an unquantifiable, otherworldly spiritual dimension in art. In his zeal to blunt Kandinsky's numinous equations, Wright asserted, "[H]e came forward and attempted to drag it back into the murky medium of metaphysics."[49] His language parallels de Zayas's earlier castigation of Stieglitz's "psychology and metaphysics," that is, his failure to embrace more forthrightly a formalist interpretative model for art.

Kandinsky and his ideas of visual rapture emerged as but one of the many contested areas of modernism as it was debated (and eventually became institutionalized) in New York in the mid-1910s. In fact, as "formalism" gradually became consolidated as a critical tool — a process that would unwind slowly after the Armory Show, then accrue weight and urgency in the late 1930s, as writers such as George L. K. Morris (1905–1975), James Johnson Sweeney (1900–1986), and Clement Greenberg (1909–1994) pressed for a more a rigorous evaluation of the inherent traits of painting — the various modernist factions became more distinct and partisan. They polarized into combative, irreconcilable camps. (Take, for example, the sparring of Greenberg and Harold Rosenberg [1906–1978]. Rosenberg's existential ethos of "action" resisted the material codifications of formalism and instead posited that the enactment of the artist's individuality counted for more than the hallmarks of a painting's composition.) Yet Stieglitz always insisted upon a middle ground, maintaining that metaphysics and Freud could be blended with Bell's prescription for "significant form." De Zayas, by contrast, remained more aloof when it came to the subject of Kandinsky. Unlike Wright, he never ventured an essay or public opinion on his work. Nor did he include Kandinsky's painting in his exhibition program at the Modern Gallery, a stance that revealed a certain indifference, perhaps even irreverence, given his predisposition toward Cubism, a movement that he had dubbed "the real 'new art'" and called "the turning point from the old to the new in painting."[50] (In the pages of *Camera Work*, Kandinsky had weighed in on Picasso, contending, "[H]is work shows in a remarkable way his desire to retain the appearance of the material things. . . . [H]e throws color overboard and paints a picture in brown and white.")[51]

O'Keeffe had obtained a copy of the catalogue for the *Forum Exhibition* probably around the time that she saw the project during its two-week run at the Anderson Galleries from 13 through 25 March 1916. (The copy in her library is inscribed 2–17 October, suggesting that she read the book on

the eve of her lecture in Texas.)[52] Wright had cast the *Forum Exhibition* as a corrective to the Armory Show, which, he believed, had occluded American modernism with its pronounced emphasis on European developments. Certainly figures such as Marcel Duchamp and Francis Picabia had commanded more press coverage than their New York counterparts, who were treated as something of a sideshow, buried in the spate of articles and reviews that grew out of what amounted to a sensation, if not an unforeseen spectacle. For instance, one of Duchamp's entries, *Nude Descending a Staircase, No. 2*, was alluded to by one New York newspaper as an "Explosion in a Shingle Factory," compounding the widespread incredulity at what the Europeans considered to be art.[53] Such excoriations, ironically, had their fringe benefits: they helped to build audiences and to strengthen the slowly growing marketplace for modernism in the United States after the Armory Show. The avant-garde was always a feeder for scandal; its outré, risk-taking compositions purposefully rattled the middle class and challenged their ethos, making particularly good fodder for the mass media. O'Keeffe had not lived in New York during the installation of the Armory Show, but the *Forum Exhibition* was a definite lure for her. Part of her impetus to take in the event was to see firsthand the work of Arthur Dove, who did not participate in the Armory Show, although other artists from the 291 stable, such as John Marin (1872–1953) and Marsden Hartley (1877–1943), had been exhibitors.[54]

Bemont had advised O'Keeffe to overlook Eddy's text in *Cubism and Post-Impressionism*, gauging the accompanying plates to be more valuable. Yet she ignored his directives when confronted with the task of delivering her talk on "aesthetics" at West Texas State Normal College. Shortly before giving her address, though, she dwelled on one illustration in Eddy's volume: Arthur Dove's pastel *Based on Leaf Forms and Spaces* (fig. 15). This work, now lost, stood out for its abstract, organic shapes that coalesced into a seductive, undulating, rhythmic pattern. And while work by Picasso, Picabia, Duchamp, and Kandinsky was reproduced in Eddy's volume, *Leaf Forms and Spaces* was treated with a bold physicality, its velvety surface both beguiling and lulling, traits that contrasted with the more cerebral, disjunctive images that made up the Europeans' compositions. Eddy avowed in his accompanying description that "[a]lmost the only man in this country who persistently painted in modern fashion prior to the International was Arthur Dove."[55] (The International was a code name for the Armory Show, underscoring its cosmopolitan reach.) Eddy's affirmation of Dove's status as a modernist forerunner — as an American artist, moreover, who had reached the crucible of abstraction independently, without the taint of Continental influence — surely must have reinforced O'Keeffe's inkling that Dove was not only an anomaly but a figure with whom she could identify. Much later,

FIG. 15

Arthur Dove, *Based on Leaf Forms and Spaces*, 1911/12. Pastel on paper, 23 x 18 in. (58.4 x 45.7 cm). Location unknown
ALM 11/12.1

FIG. 16

Arthur Dove, *Plant Forms*, 1911/12. Pastel on canvas, 17¼ x 23⅞ in. (43.8 x 60.6 cm). Whitney Museum of American Art, New York. Purchase, with funds from Mr. and Mrs. Roy R. Neuberger
ALM 11/12.7; DBB PL. 8

FIG. 17

Arthur Dove, *Connecticut River*, 1912/13. Pastel on linen, 17¾ x 21¼ in. (45.1 x 54 cm). Indiana University Art Museum, Bloomington. Jane and Roger Wolcott Memorial, Gift of Thomas T. Solley
ALM 12/13.2

in the mid-twentieth century, once she had begun to sift through and assess the cultural framework of sources and derivations that had been projected on her work — a process that she also carefully canalized and crafted (with input from Stieglitz), having long since become acculturated to the mindset and priorities of the media — she would aver, "I discovered Dove and picked him out before I was picked out and discovered. Where did I see him? A reproduction in a book. The Eddy book, I guess, a picture of Fall leaves. Then I trekked the streets looking for others. In the Forum Exhibition there were two or three — then there were more."[56]

O'Keeffe's trek to the *Forum Exhibition* would have brought her into contact with Dove's *Plant Forms* (fig. 16) and *Connecticut River* (fig. 17), pastels that were allied with *Leaf Forms and Spaces* as well as with a string of ruminations on nature and its ephemeral elements, such as *Movement No. 1* (plate 5), *Sails* (fig. 18), and *Nature Symbolized No. 2* (see fig. 78), many of which he had shown at 291 and later at the Thurber Galleries in Chicago in 1912.[57] Dove's probing of nonillusionistic space in these works, together with his abstraction of vegetal shapes into symmetrical, quasi-repetitive

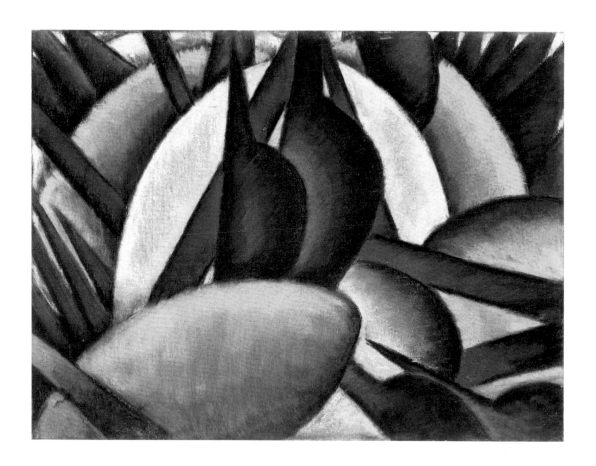

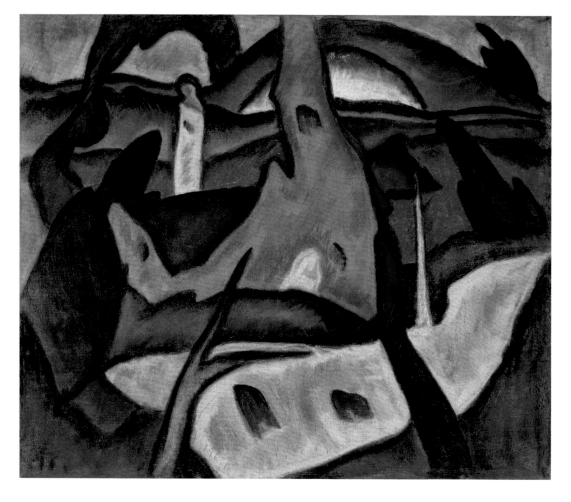

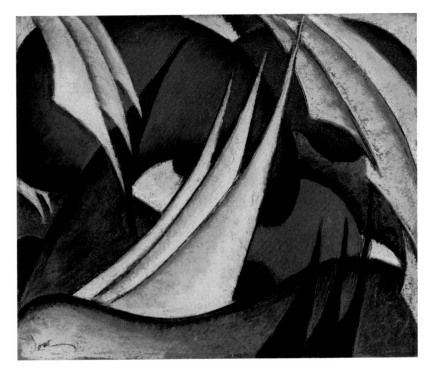

FIG. 18

Arthur Dove, *Sails*, 1911/12.
Pastel on composition
board, 17⅞ x 21½ in.
(45.4 x 54.6 cm). Terra
Foundation for American
Art, Chicago. Daniel J.
Terra Collection, 1993
ALM 11/12.8; DBB PL. 11

designs, had a lasting impact on O'Keeffe, becoming embedded not only in
her memory but in her own visual lexicon. Dove's pastels emerged, then,
not only as a significant progenitor to O'Keeffe's radical reformulations of
nature but as a footprint that partially marked the subsequent course of
her work. In her charcoal drawings of 1916 (figs. 19 and 20), putting behind
her any lingering evocation of Dow and his preference for flatness and the
refinement of natural form, O'Keeffe purged her work of decorative fussiness
and an obvious debt to Art Nouveau line.

O'Keeffe's output, perpetually characterized by variation, wandered
in multiple thematic directions. But after she encountered Dove's pastels
at the *Forum Exhibition*, her distillations of nature became more efficient
and rigorously honed. Her painting, at least through the 1920s, was more
engaged in stretching the known precepts of modernism and illuminating its
American dimensions and forms. In short, after she saw the work of Arthur
Dove, she sensed an alternative aesthetic path to Cézanne and his reasoned,
methodical reworkings of nature (and whose work had been established by
Bell, de Zayas, and Wright as the benchmark of modernism, determining
its later criteria and future patterns). She sensed that intuition could yield
equally momentous, groundbreaking painting. Kandinsky had already primed
her for this possibility with his imperative of an "inner necessity" in art. But
in Dove's pastels she found living, palpable examples.

When O'Keeffe retrospectively mulled over her linkages to Dove's work,
she would maintain, "Dove is the only American painter who is of the earth.
You don't know what the earth is, I guess. Where I come from the earth means

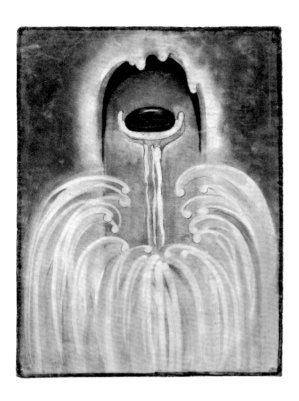

FIG. 19

Georgia O'Keeffe, *No. 2—Special*, 1915. Charcoal on paper, 23⅝ x 18¼ in. (60 x 46.3 cm). National Gallery of Art, Washington, D.C. Alfred Stieglitz Collection, Gift of The Georgia O'Keeffe Foundation

BBL 45

FIG. 20

Georgia O'Keeffe, *I—Special*, 1916. Charcoal on paper, 24¾ x 18¾ in. (62.9 x 47.6 cm). National Gallery of Art, Washington, D.C. Alfred Stieglitz Collection, Gift of The Georgia O'Keeffe Foundation

BBL 116

everything. Life depends on it. You pick it up and feel it in your hands."[58] By the time she made this declaration, O'Keeffe was referring to Abiquiu, New Mexico, the site that had become her geographic mainstay and home as of 1929. Thereafter, her contact with New York was limited to annual visits to see Stieglitz and a vacation each summer at Lake George. Dove never traveled to the Southwest. He never ventured much beyond Manhattan, the peripheries of Long Island Sound, and the Finger Lakes region of upstate New York, where he spent his childhood, with the exception of one early trip to France in 1908–9, when he spent the bulk of his time outside Paris.[59] O'Keeffe's allusion to Dove being "of the earth" redounded in multiple interpretations, the foremost of which centered on the robust, uninhibited nature of his work and its American extension of an essentially foreign expression. Whatever his antecedents, O'Keeffe knew that Dove had reached the forefront of modernism instinctually and with such ease that history had little bearing on his development. When she thought about the ubiquitous comparisons made between his work and that of Kandinsky, she would assert, "I think Dove came to abstraction quite naturally. . . . It was his way of thinking. Kandinsky was very showy about it, but Dove had an earthy, simple quality that led directly to abstraction. His things are very special. I always wish I'd bought more of them."[60] Kandinsky's theories in *Concerning the Spiritual in Art* may have been a vital ingredient in her artistic education, but, as O'Keeffe construed it, Dove had the edge and had exceeded him as a painter.

A virile and profound talent

Arthur Dove (fig. 21) had figured prominently in Eddy's *Cubists and Post-Impressionism*, the first survey of modern art written by an American. Eddy, a lawyer and collector from Chicago, had purchased several works, including paintings by Kandinsky, from the Armory Show when it traveled to his native city in mid-1913.[61] He also saw himself as an educator; hence his focus on modernist art that came on the heels of the International. However, the eccentricity and vagueness of his chapters and groupings, under headings such as "ugliness" and "esoragoto," along with his crusading pedagogical tone, clearly alienated Alon Bemont, who had advised O'Keeffe to skip Eddy's exegesis and concentrate on the plates. Dove was the only figure from the Stieglitz circle included in Eddy's quirky account of modernism. Although a listing of Stieglitz's exhibitions at 291 appeared in an appendix — one of the first in a series of accolades that would grow into celebratory tributes extending well into the mid-1930s, as Stieglitz's standing and prescience as New York's principal arbiter of modernism was continually questioned — none of the American artists that he had shown, such as Marin, Hartley, and Max Weber (1881–1961), were admitted into Eddy's idiosyncratic canon.[62] But then Eddy had not purchased work by any of these artists at the Armory Show. He was more taken by Kandinsky, by such revelatory and transcendent paintings as *Improvisation No. 29* (1912, Philadelphia Museum of Art) and *Improvisation No. 30 (Cannons)* (1913, Art Institute of Chicago), which he not only acquired but reproduced in his book.

Cubists and Post-Impressionism can hardly be considered an impartial study. It is a self-serving document, proselytizing not only for modernism but for Eddy's own foresight as a collector. All of the illustrations were drawn from works in his collection, hence, the uneven coverage and the absence of an overarching narrative, resulting in a text that largely mixed biography and opinion (which was presented and veiled as history). Eddy was just as ambitious as Stieglitz when it came to the heady cause of modernism: he tagged his identity to its risk-taking associations. The marketplace for art, at that time a relatively unknown commodity, grew very gradually in the United States until the late 1950s, when the value of painting as an investment became recognized. This helped to compound Eddy's sense of audacity. He was the second-largest buyer at the Armory Show, after John Quinn, the legal consul for the event and a collector from New York, who would outpurchase all other patrons. (Walter Arensberg, Katherine Dreier, and Albert Eugene Gallatin made more modest acquisitions).[63] With his renegade stance and

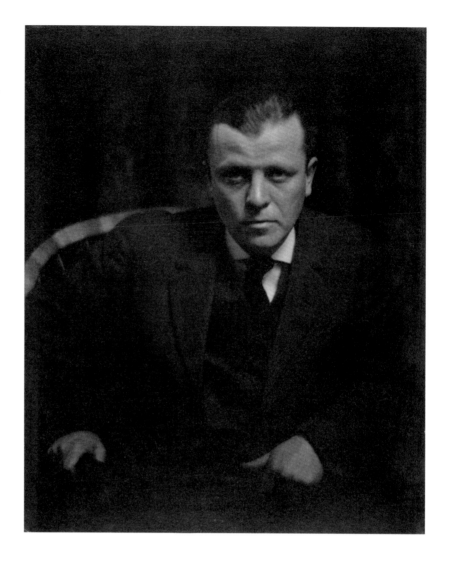

evangelizing mission, Eddy emerged as a cultural contender in the United States in the early twentieth century. However, like Quinn, he remained cautious in his collecting habits, never becoming as confident or as brazen as their expatriate counterpart Gertrude Stein, who was more fully immersed in avant-garde culture in Paris as a writer of highly inventive, reflexive prose whose fragmented structure recalled Cubist painting.

For all of his euphoria for modernism, Eddy was never able to embrace completely the progressive American artists associated with the Stieglitz circle — that is, with the salient exception of Arthur Dove. Eddy may have regarded Stieglitz as exemplary, if not as a competitor, but as Stieglitz divested his exhibition program of European figures in the wake of the International to focus on homegrown elaborations of the avant-garde, Eddy's interest waned. His purchases remained confined to American artists who had direct contact with modernist movements forged on the Continent, such as Albert Bloch (1882–1961), who was associated with Der Blaue Reiter in Munich until its collapse in 1914; Kandinsky, one of the movement's founders, had pressed Eddy to consider Bloch's work for his collection, commending

the "gains in the form of his inner expression."[64] Similarly, Eddy drifted toward the painting of Leon Kroll (1884–1974), whom he was able to fit within an Impressionist schema, as he continued to tie American art to foreign prototypes, never entirely sanguine that its expressions could develop independent of Continental influence. Even Winslow Homer (1836–1910), John Singer Sargent (1856–1925), James McNeill Whistler (1834–1904), and George Inness (1825–1894) found a place within Eddy's Impressionist typology. In 1919, he declared, "*Better pictures are being painted in America today than Homer painted*, and he would be the first to say so if living."[65] Eddy's taste, however variable, was always a factor in his assessment of art, as were considerations of the marketplace.

Eddy had bought Dove's *Leaf Forms and Spaces* when his first exhibition at 291 moved on to Chicago's Thurber Galleries in 1912. He was forthright in asserting in *Cubists and Post-Impressionism* that Dove was "[a]lmost the only man in this country who persistently painted in modern fashion prior to the International." However, the accolade came with the qualification that Dove did not completely measure up to his peers in Europe and lagged behind their prescience (a position that Eddy later reversed when the second edition of the book was published in 1919).

For *Cubists and Post-Impressionism*, Eddy had solicited a statement from Dove himself, which he printed in its entirety, conspicuously forgoing any analysis of its content. One of the first descriptions of Dove's intentionality, it also provides a glimpse into his early self-fashioning. Dove began by declaring his dependence upon nature, which he deemed inseparable from art. At the outset, he contended:

> After having come to the conclusion that there were a few principles existent in all good art from the earliest examples we have, through the Masters to the present, I set about it to analyze these principles as they are found in works of art and in nature.
>
> One of these principles which seemed most evident was the choice of the simple motif. This same law held in nature, a few forms and a few colors sufficed for the creation of an object.
>
> Consequently I gave up my more disorderly methods (impressionism); in other words, I gave up trying to express an idea by stating innumerable little facts, the statement of facts having no more to do with the art of painting than statistics with literature.[66]

Unlike Kroll and other American Impressionists, Dove had little use for messy daubs of paint posing as an empirical method; he found these painters' compositions too vague and indeterminate, with their patterns of light

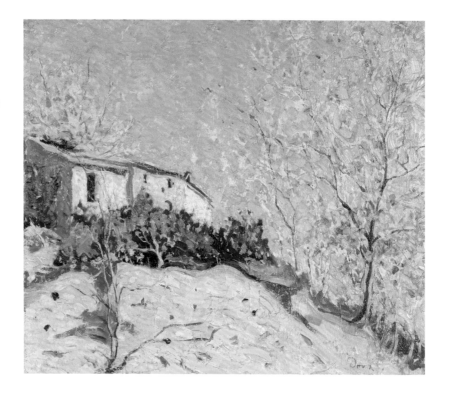

pressed into service to document an optical rather than an interior experience. He had succumbed to this same means of expression in *Landscape, Cagnes* (fig. 22), painted during his yearlong stint in France, where he had retreated to capture the luminosity of the Mediterranean coast while avoiding Paris and its demands that he become conversant with the new paradigm of Cubism. However, Dove's paintings from this period were admittedly hesitant and unextraordinary, their viscous application of paint and neutral subject matter rarely straying from Impressionist conventions. In fact, he would later concede that they represented a "blind alley."[67] To offset his sense of futility, once he returned to the United States he engaged in a more rigorous investigation of nature by tracking its myriad holdings of flora and fauna, growth patterns, and interconnected systems. According to Helen Torr, a painter who became Dove's second wife, "he spent much time in the woods analyzing tree bark, flowers, butterflies etc." near his family home in Geneva, New York.[68] Thereafter, his work was transformed, becoming immediate, assertive, and startling. What he had once cast as an impression was now organized into a palpable, clear design evoking the resplendent, transient dimensions of the natural world.

Dove's overhaul of his imagery resulted in an outright abstraction of form for which there was little internal foreshadowing. In *Abstraction No. 3* (plate 1), for example, with its broad black outlines, tumescent organic shapes are rendered as bold generalizations of a landscape, unencumbered by any literal reference or specificity. Such compositions subsequently fed the pastels that he showed at his 1912 exhibition at 291, in which he more fluidly and audaciously rendered the underlying rhythms that animate nature.

The teeming profusion of curvilinear and quasi-rectilinear vegetal shapes in *Plant Forms* (see fig. 16), as well as in *Leaf Forms and Spaces* (see fig. 15), proclaimed a more confident expression of nature's dynamism. Unlike the murkier, more ponderous earthen tones of *Abstraction No. 3*, these pastels were invested with a distinct radiance, returning to the one pictorial element that had held Dove in France. Of the vibrant color that saturates these images he wrote, "There was a long period of searching for something in color which I then called 'a condition of light.' It applied to all objects in nature, flowers, trees, people, apples, cows. These all have their certain condition of light, which establishes them to the eye, to each other, and to the understanding."[69]

But what was it about Dove's new surety of purpose that caught Eddy's attention and generated his enthusiasm for *Leaf Forms and Spaces,* as well as his entry on Dove in his volume on modernism? Stieglitz factors significantly into any such accounting, as Dove's dramatic about-face took place soon after their introduction in late 1909 or early 1910.[70] While the lineup of exhibitions at 291 no doubt reinforced that Impressionism was no longer an operative model — long defunct since Cézanne's reconstitution of form in the late nineteenth century — Dove now came into contact with such American artists as Marsden Hartley, John Marin, and Max Weber, who were similarly grappling with European influence and its implications for the origination of a domestic modernism. As Weber advised Dove on the remnants of Impressionism in the United States, "it isn't what you see there; you must always symbolize."[71]

Dove had met Stieglitz through Alfred Maurer (1868–1932), who engineered an introduction to Manhattan's reigning cultural renegade for him when he returned from France. Regardless of Dove's self-imposed seclusion abroad, he had interacted with a small coterie of expatriates, including Maurer, Weber, Jo Davidson (1883–1952), Arthur B. Carles (1882–1952), and Patrick Henry Bruce (1881–1936), all of whom had congregated in Paris, seeking proximity to a more exhilarating intellectual discourse than New York could offer (fig. 23). And while Gertrude Stein's weekly salons, which drew an international mix of artists and writers, were within Dove's social reach, he was too diffident to act on any overture to join them, preferring the company of his American confreres or the isolation of the French landscape.[72] His seeking out of Stieglitz upon his return to New York was the one forthright professional move that he made in his life. Once quickly cemented, the tie absolved him of any further need for networking. Dove seemed to be constitutionally incapable of forwarding himself, let alone of plotting a career path or hustling. (The economic gains for any American avant-garde artist were, moreover, limited and dispiriting, permitting Stieglitz's emboldened and romantic claims for his circle's "authenticity" as modern artists.)

FIG. 23

Arthur Dove in Paris,
c. 1908–9. The Estate of
Arthur Dove

Prior to his trip to France, Dove had worked as a freelance illustrator
for *Century*, *Cosmopolitan*, and *Life* (at the time, before its reincarnation by
Henry Luce in 1936, it was a general interest publication, replete with humor
and copious illustrations pertaining to the beau monde). The restrictions
imposed by these publications, however, had kindled his desire for a more
independent, unconstrained creative outlet, leading to his foreign pilgrimage.
He had high expectations that he could overcome the pedestrian experience
of churning out hackneyed images conforming to the prevailing taste for a
Gibson-girl type model.[73] But then Impressionism turned out to be just as
quotidian and restricting.

Soon after Dove met Stieglitz, he was folded into the *Younger American
Painters* exhibition at 291. The project was the first such venture in Manhattan
to gather together and highlight those figures whom Stieglitz had designated
as part of a cohesive, like-minded entity formed in contrast to Europeans
such as Rodin, Henri de Toulouse-Lautrec (1864–1901), and Henri Matisse
(1864–1954), whom he had already featured in his gallery. Such projects were
a departure from Stieglitz's early mandate to foreground photography and
overturn its status as a spurned media by placing it on par with the output
of European painters who had been tested in Parisian salons and the press.
Stieglitz had quickly tired of the squabbling of his photographic peers, of
their dissensions and inability to achieve consensus regarding photogra-
phy's pictorial possibilities and independence from commerce; he found that
painting was more self-assured. In fact, he boycotted the work of the splinter
groups and factions that had countered the Photo-Secession, the tightly knit

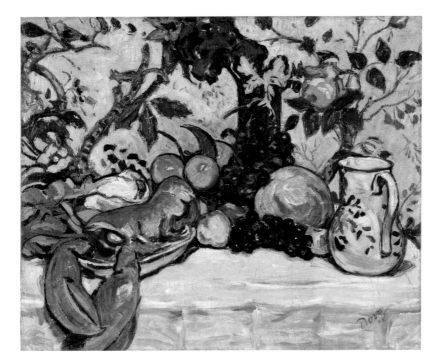

group of pictorialists that he had assembled and whose members included Alvin Langdon Coburn (1882–1966), Gertrude Käsebier (1852–1934), Eva Watson-Schulze (1867–1935), Edward Steichen (1879–1973), and Clarence White (1895–1971), among others. As the debates concerning photography's status and goals escalated internationally in 1904 and 1905, and as its practice became institutionalized within staid societies such as the American Federation of Photography (whose first exhibition, in 1904, was juried by William Merritt Chase, among other painters), Stieglitz had become alienated by the rampant academicism and mediocrity of a medium that was of paramount importance to him and whose integrity, he insisted, must lead to its acknowledgment as art.

Stieglitz's *Younger American Painters* in 1910 included, in addition to Dove, Carles, Hartley, Marin, Maurer, Steichen, Weber, and others, artists bound primarily by national identity and a commitment to experimentation. Dove exhibited *The Lobster* (fig. 24), a work that he had earlier placed in the Salon d'Automne in Paris in 1909. Whatever its indebtedness to Matisse, evident in the telltale black outline that had become a staple of much Post-Impressionist painting, it was nevertheless singular enough to warrant admission to Stieglitz's statement on the American iterations of modernism — his calculated reply both to the detractors of the Photo-Secession and to its own increasingly restrained sensibility.

The instant bond that Dove and Stieglitz forged upon meeting would last a lifetime. For Dove, Stieglitz filled in for an emotionally withholding and distant father who disdained his avocation as an artist, preferring that his

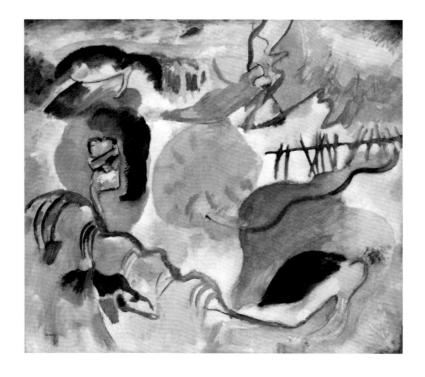

son pursue a more financially secure, more socially recognized profession.
(Dove's recalcitrance on this issue resulted in his eventual disinheritance,
a portion of which would later be restored by his mother.) The fortification
that Dove felt from Stieglitz resulted in the unwavering, poised declara-
tions about painting that he made at the time of his 291 exhibition. When
his pastels traveled to the Thurber Galleries, he informed one reviewer for
the *Chicago Examiner*, "Yes, I could paint a cyclone. Not in the usual mode of
sweeps of gray wind over the earth, trees bending and a furious sky above.
I would paint the mighty folds of the wind in comprehensive colors; I would
show repetitions and convolutions of the range of the tempest."[74] The resem-
blances of these works to *Movement No. I* (plate 5) are striking, emerging
as an enactment of his growing study of epistemology and the intersections
between nature and culture.

The mix of rhapsody and aplomb in Dove's riff on a "cyclone" no doubt
persuaded Eddy of his singularity and worth. Dove's "independence" from
preexisting European models was soon established by Stieglitz during the
height of the Armory Show, the venue from which Dove was conspicuously
absent but nevertheless insinuated into some of its reviews.[75] Kandinsky
was one artist who had figured prominently in the event, his inclusion even
prompting Stieglitz to purchase his painting *The Garden of Love (Improvisa-
tion Number 27)* (fig. 25). Thereafter, the two engaged in correspondence that
touched on the possibility of Kandinsky showing his work at 291, a project
that was never realized.[76] Dove probably saw Kandinsky's painting soon after
its acquisition by Stieglitz, but there is no evidence that he attended the

Armory Show, or even the less visible installation of contemporary German graphics held at the New York branch of the Berlin Photographic Society in December 1912, in which Kandinsky's work also appeared.[77]

Whatever Dove's presence at 291, he was now ensconced in Westport, Connecticut, where he had purchased property. As Dove attempted upon his return from France to eke out a living as a farmer while still working as an illustrator, his output as an artist became episodic and dwindled, making him even more dependent on Stieglitz as a lifeline. (His social life in Westport did include contact with residents such as John Marin, the literary critic Van Wyck Brooks [1886–1963], the writer Sherwood Anderson [1876–1941], the journalist Paul Rosenfeld [1890–1956], and the photographer Paul Strand [1890–1976], all of whom were connected to Stieglitz, extending his conversation and ethos.) Dove had become acquainted with Kandinsky's ideas through *Camera Work*, but the extract from *Concerning the Spiritual in Art* was not published until July 1912, several months after his own show had closed. Any connection Dove had to Kandinsky's thought was tangential, having passed through the intermediary of Stieglitz and his meandering aesthetic preoccupations.[78] That Dove never referenced Kandinsky in his letters to Stieglitz underscores a limited engagement with his theory, while simultaneously bolstering Dove's proclamation, "I could not use anothers philosophy except to help find direction any more than I could use anothers art or literature."[79]

Yet there were broad correspondences that obtained between Dove and Kandinsky, most of which pivoted on their analogies of painting to music (plate 29). These parallels, though, always remained vague, subsumed within a larger intellectual inquiry into the equivalence of the arts that surfaced in the work of numerous artists, both European and American, around 1912–13, including Hartley, Abraham Walkowitz (1880–1965), Stuart Davis (1892–1964), and later O'Keeffe (fig. 26). These analogies were but one aspect of Dove's ongoing abstraction of nature, a component of his larger metaphysical stratagem. Certainly, Eddy did not wrap Dove into his section on Kandinsky in *Cubists and Post-Impressionism*; he never advocated that "The New Art in Munich" — as his chapter on German Expressionism was titled — reverberated within the United States at all, with the exception of the work of such figures as Albert Bloch. (Marsden Hartley's stint in Berlin in 1914 was not included, since his "German officer" series unfolded after Eddy's manuscript had been completed, and it was not added to the 1919 edition.) And Eddy was not entirely prescient when he designated Dove a "Fauve," a label that did not fit, given the artist's transcendental goals. But one of Eddy's last sections, on "Virile-Impressionism," anticipated the language used to describe the work of both Dove and O'Keeffe in the early 1920s, as well as

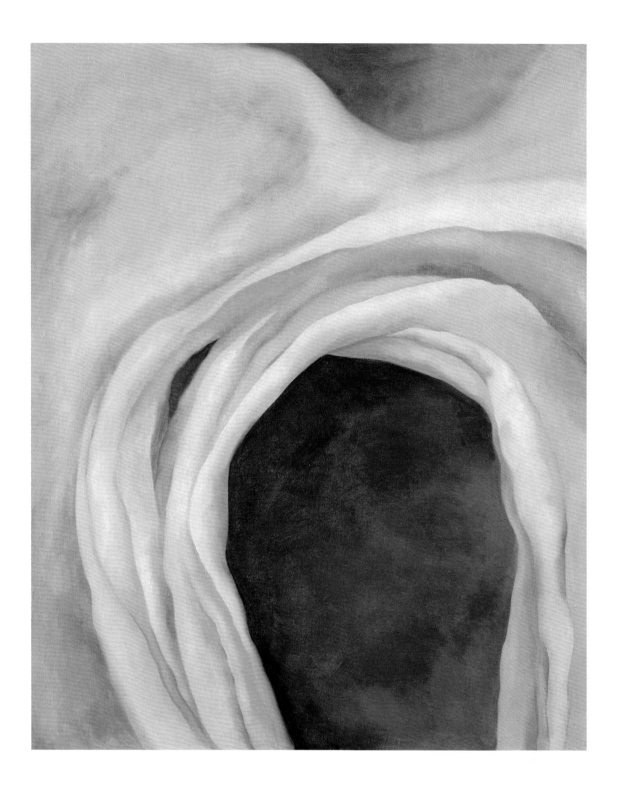

that of other American modernists, such as Marin and Hartley. Dove and
O'Keeffe, however, were subjected to a more intense piling on of sexualized
references, paired in a metaphoric coupling soon after O'Keeffe became a
staple of Stieglitz's circle.

In *Cubists and Post-Impressionism*, Eddy asked, "What is happening in
America?" and concluded with the pronouncement, "Exactly what might be
expected in a *young*, *vigorous*, and *virile* country. . . . [T]he development of
American art has been along independent lines—at least along *one*

independent line, a line so individual in its characteristics it deserves the name
American-Impressionism, or, more generically, Virile-Impressionism. . . . [that
is] quite different from the more superficial refinements of Impressionism."[80]
His use of this catchall terminology was not nearly as daring and far-reaching
as it could have been. While he averred, "We are a nation of inventors *because*
we are a nation of dreamers,"[81] his reverie on a native, masculinized Impres-
sionism did not stretch beyond Winslow Homer and James McNeill Whistler,
an odd endpoint for a book on the progressive traits of modernism and its
American extensions. The designation "Virile-Impressionism" never became
an entrenched tag, but the idea of an American artist marking his work with
his "virility" would have far-reaching implications, becoming a means for
subsequent writers to discuss Dove's paintings.

Paul Rosenfeld (fig. 27), who became close to Dove in Westport, even as
Dove's output dwindled in the mid-1910s to the occasional charcoal drawing
and pastel such as *A Walk: Poplars* (fig. 28) or paintings such as *Thunderstorm*
(plate 28), dwelled on Dove's "virile and profound talent," contending that
"[a] tremendous muscular tension is revealed in the fullest of the man's
pastels. . . . A male vitality is being released. . . . And in everything he does,
there is the nether trunk, the gross and vital organs, the human being as the
indelicate processes of nature have shaped him."[82] Rosenfeld's language,
clearly appropriated from Eddy, was enlarged through a burgeoning acquain-
tance with Sigmund Freud, whose texts had been translated in the United
States as of 1914 by A. A. Brill, the founder of the American Psychoanalytic
Society, who was socially connected to Stieglitz.[83] As Marius de Zayas and
Willard Huntington Wright propounded their concept of a "plastic expression,"

limiting their analysis to the formal unities of painting, Rosenfeld and his
colleague Waldo Frank (1889–1967; fig. 29) would counter in the *Seven Arts*,
their short-lived publication of 1916–17, that some accounting of the mean-
ings of art was in order. More specifically, they believed that the embodied
sexuality of the artist could not be overlooked or discounted, since it was
tied to the authenticity of American art and literature.

Rosenfeld and Frank pressed for the originality of Stieglitz, as well as
for that of Sherwood Anderson: they were twin exemplars of their emerging
aesthetic criterion. As Frank stated shortly after the *Seven Arts* folded, "No
art was more backward in America than painting. In less than ten years, no
art was more progressive: no art had so intelligent and compact a public. . . .
'291' is a religious fact: like all such, a miracle."[84] Their bolstering came at an
opportune moment, as by 1916 de Zayas's maneuvers to unsettle Stieglitz's

FIG. 29

Alfred Stieglitz, *Waldo Frank*,
1920. Palladium print, 9³⁄₈ x
7⁷⁄₁₆ in. (23.8 x 18.9 cm).
National Gallery of Art,
Washington, D.C. Alfred
Stieglitz Collection

authority and prowess had escalated into attacks on his "psychology and metaphysics." Whatever strides de Zayas and Wright had made for the "constitutional qualities which pervade all great works of art," as the latter put it,[85] they soon were offset and diminished by the Freudian discourse of Rosenfeld and Frank, in addition to that of the numerous journalists who became hooked on the sexual overtones of this psychological rhetoric. Both de Zayas and Wright abandoned criticism in the early 1920s, and formalism consequently suffered a setback in New York. It would be revived as a methodology only at the height of the Great Depression, by George L. K. Morris, James Johnson Sweeney, and later Clement Greenberg and others. By that point, the writings of de Zayas and Wright had suffered an irreversible fate. They were never resituated as American forerunners of a discourse that isolated and prized compositional purity and that culminated in such movements such as Abstract Expressionism and the New York school.

The fact that Dove exhibited only two pastels at the *Forum Exhibition* in 1916 — works, moreover, that were already known from his exhibition at

291 four years earlier — revealed the entrapment of farming, since the time and labor Dove required to tend to his chickens and crops, along with ongoing financial setbacks, resulted in diminished time to paint. Dove's loss of momentum in his studio became a recurring subject in his correspondence with Stieglitz. In May 1917, for example, he wrote, "I hope to be painting again by the first of June, if things go no worse, but the future for anything here doesn't look very bright."[86] To supplement his income he was forced to resort to his old standby of illustration, a medium that gave him no gratification. Its constraints on subject matter now felt oppressive, allowing him little or no room for invention. In the midst of this downturn, Stieglitz privately questioned whether Dove would ever paint again, or be able to act on the promise of the pastels he had exhibited in 1912.[87] Yet Dove's statement for the *Forum Exhibition* catalogue — which O'Keeffe read as she prepared for her talk at West Texas State Normal College in January 1917 — was filled with a mix of exuberance, longing, and anticipation, intensified by his sense that American art was poised at a pivotal juncture, that his work could no longer be construed solely as a "condition of light," as visual radiance had to be tied to his subjectivity or interior life. There he proclaimed:

> I should like to enjoy life by choosing all its highest instances, to give back in my means of expression all that it gives to me: to give in form and color the reaction that plastic objects and sensations of light from within and without have reflected from my inner consciousness. Theories have been outgrown, the means is disappearing, the reality of the sensation alone remains. It is that in its essence which I wish to set down. It should be a delightful adventure. My wish is to work so unassailably that one could let one's worst instincts go unanalyzed, not to revolutionize nor to reform, but to enjoy life out loud. That is what I need and indicates my direction.[88]

The prevailing theories of art, in Dove's view, were too limited and one-sided, too stuck in ideas of pictorial revolution rather than in descriptions of the origins of these sensations. In his statement, he wrote that a balance of explanations was required if criticism was to be renewed and become efficacious, especially since the identity of American modernism was at stake, and with it the possibility of gaining some foothold within an international artistic community. Although Dove's language was characteristically aphoristic, in addition to cathartic and giddy, his desire to resume painting and add to modernism's contemporary reformulations emerged as a metaphor for the new meanings that American art would soon acquire.

Prior to the *Forum Exhibition*, Dove had purposefully steered clear of aligning himself with a specific cause, ideology, or subset of modernism,

announcing in one of his first letters to Stieglitz that "the modern painting does not represent any definite object, neither does 291 represent any definite movement in one direction, such as, Socialism, suffrage, etc. Perhaps it is these movements having but one direction that make life at present so stuffy and full of discontent."[89] This affirmation grew out of a solicitation Dove had received from Stieglitz in late 1914 for a special issue of *Camera Work*, to be titled, "What is '291'?" another of Stieglitz's gestures to consolidate his dominion in the wake of the Armory Show. Although Stieglitz replied that Dove's "contribution is very fine,"[90] reinforcing Dove's assumption that painting was a politically neutral entity, politics would soon encroach upon this sense of virtuosity, disturbing whatever equilibrium (and oasis) Dove had once found in the programs at 291. For soon after O'Keeffe became connected with Stieglitz in 1916, offsetting the stable of "fellows," as Stieglitz called the male painters who had overwhelmed his lineup of exhibitions,[91] the critical rhetoric shifted dramatically, becoming not only more distinctly partisan but inflected with Freudian ideas and a greater focus on issues that related to gender and the artist's sexuality.

Around 1921, the circumstances of Dove's life changed radically. In addition to leaving his wife, son, and farm in Westport to live with Helen Torr, or Reds, as she was known to friends (figs. 30 and 31), he began painting on a more diurnal basis — a move that was accompanied by increased economic hardship but led to years of domestic stability and happiness. The rupture occasioned his resurrection after a considerable hiatus by numerous writers who would position him as a progenitor of American modernism, a figure who had the capacity to direct its future. As Sherwood Anderson wrote soon after Dove recommitted to painting, "[T]here is some faint promise of rebirth in American art but the movement may well be a stupid reaction from Romanticism into realism — the machine. To be a real birth the flesh must come in. And that's why, I suppose, I have since seeing the first piece of your work, looked to you as the American painter with the greatest potentiality for me."[92] This characterization was also circulated by Paul Rosenfeld. In the *Dial* in late 1921, he similarly elaborated on Dove's "virile and profound talent," making a case for the heightened masculinity that pervaded his work and its key role in redefining an indigenous modernism. Yet O'Keeffe, who had sought out Dove after her encounter with his work in Eddy's volume, would soon be paired with him. This metaphoric coupling expanded a discourse grounded in a more intuitive, sensual approach to nature, an approach that would be branded as uniquely American.

FIG. 30

Arthur Dove and Helen Torr
Dove, c. 1920. The Estate
of Arthur Dove

FIG. 31

Arthur Dove, *Reds*, c. 1926.
Collage of paper, silk,
watercolor, pencil, and a
lock of hair, 8¾ x 9¼ in.
(22.2 x 23.5 cm). Fine Arts
Museums of San Francisco.
Museum purchase,
Achenbach Foundation for
Graphic Arts Endowment
Fund, Friends of Ian
McKibbin White Endowment
Fund and William H. Noble
Bequest Fund
ALM 26.5

Two of a kind

In April 1917, Georgia O'Keeffe exhibited her work at the final show at 291 — a group of vibrant watercolors, charcoal drawings, and a few oil paintings (figs. 32–36). It was in these works that her connections with Dove started to surface, suggesting that her prolonged consideration of his work in the wake of the *Forum Exhibition* had begun to congeal into a loose debt. Nevertheless, the overall arc of her painting was still amorphous, comprised of a range of genres including studies of the nude body and of the landscape that subtly, and perhaps unconsciously, linked the curvature, folds, and undulations of each entity as like forms with similar properties (figs. 37–39). Amid this unwieldy span of themes (which still included watercolors and illustrations derived from Art Nouveau conventions), her *No. 24 — Special/No. 24* (plate 2), with its muted palette and feathered brushwork, acknowledged paintings such as Dove's *Abstraction No. 3* (plate 1), as well as his pastels such as *Plant Forms* (see fig. 16).[93] Their abstract compositions and nonillusionistic rendering of nature, of its spaces and mutable forces, were in sync, alluding to influence and close study.[94] However, O'Keeffe also worked assiduously during this period to intensify her palette, a process that Dove would put off until the early 1920s, and so works such as his *Drawing [Sunrise II]* (plate 3) and *Abstraction, Number 2* (plate 4) are more the norm.[95] As O'Keeffe wrote to Anita Pollitzer on the eve of this transition, in early 1916, before the group show at 291 that would situate her as "a woman on paper," "I haven't done anything with color for ages — haven't wanted to — but I think Im going to watercolor evenings — again — from 4 till six — outdoors. . . . Wouldn't it be great if you were here watching the sunset by me — Its almost gone — wonderful blue grey — pink and orange — Ive been thinking lots about colors — I think that Im going to use different ones — but — Im not wanting to try as much as I ought to because maybe I cant do what Ive been thinking — However — Ill try — ."[96]

Her "watercolor evenings" redounded in such works as *Train at Night in the Desert* of 1916 (plate 49), with its abstract, billowing cloud of smoke set against a dark encompassing sky, as well as their diurnal opposite: *Sunrise* (plate 17), animated by pulsating bands of color, and *Morning Sky* (fig. 40), in which a ray of light is simplified to a few geometric shapes — works that would become among the most radical enunciations of nature in the early twentieth century. However, for all of their formal reduction, when works such as *Blue I* (plate 6) appeared in her first one-person show at 291 in 1917, the inventive traits of these watercolors and their bold recasting of the transient dimensions of the landscape almost wholly eluded the critics. For

FIG. 32

Alfred Stieglitz, *Georgia O'Keeffe Exhibition at 291 (Room to Right — Wall to Right from O'Keeffe Exhibition)*, 7 April 1917. Gelatin silver print, $6^5/_{16}$ x $8^5/_8$ in. (16.1 x 21.9 cm). The J. Paul Getty Museum, Los Angeles

FIG. 33

Alfred Stieglitz, *Georgia O'Keeffe Exhibition at 291 (Room to Right — Facing Door Going Out from O'Keeffe Exhibition)*, 7 April 1917. Gelatin silver print, $7^3/_{16}$ x $9^3/_{16}$ in. (18.3 x 23.3 cm). The J. Paul Getty Museum, Los Angeles

FIG. 34

Alfred Stieglitz, *Georgia O'Keeffe — Exhibition at 291*, 1917. Gelatin silver print, $7^1/_2$ x $9^5/_8$ in. (19.1 x 24.4 cm). National Gallery of Art, Washington, D.C. Alfred Stieglitz Collection

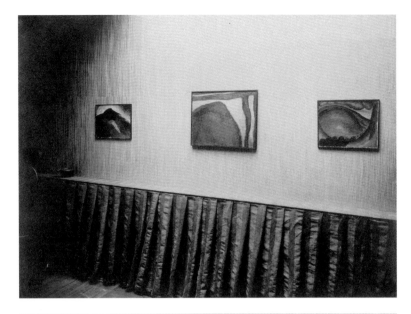

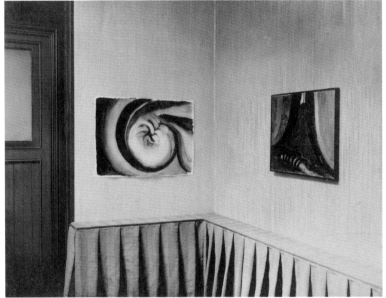

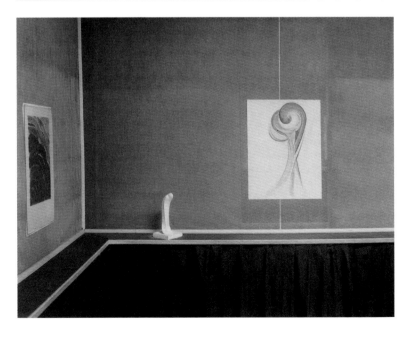

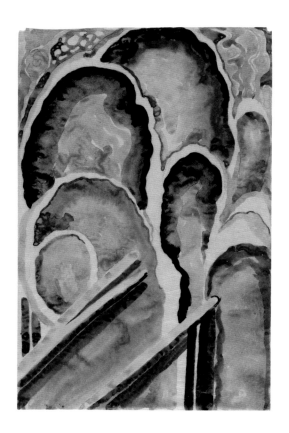

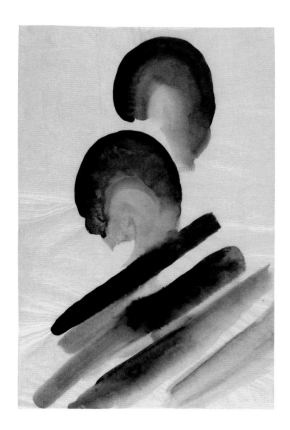

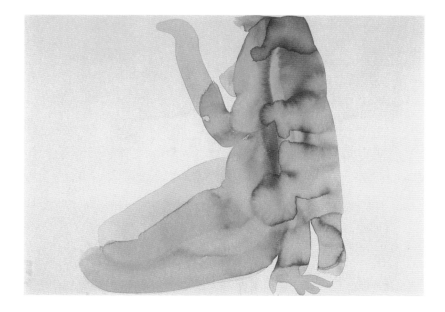

example, Henry Tyrrell of the *Christian Science Monitor* exclaimed, "There is an appeal to sympathy, intuition, sensibility and faith in certain new ideals to which her sex aspires. For there can be no mistaking the essential fact that Miss O'Keefe [*sic*], independently of technical abilities quite out of the common, has found expression in delicately veiled symbolicalism for what every woman knows, but what women heretofore have kept to themselves, either instinctively or through a universal conspiracy of silence."[97] Stieglitz clearly took note of Tyrrell's reading, particularly its foregrounding of O'Keeffe's

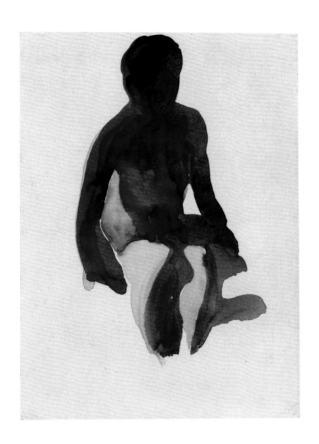

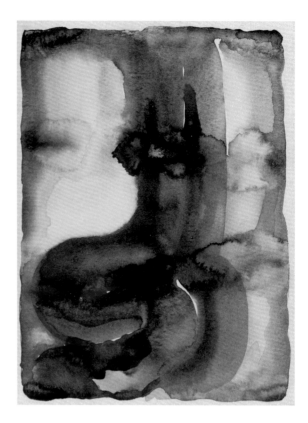

femininity and the underlying assumption that gender could account for differing aesthetic priorities. These sexual contrasts set the tone for subsequent interpretations, as Stieglitz and neo-Freudian writers such as Rosenfeld and Frank loomed conspicuously in the background of Tyrrell's thinking. Tyrrell gave O'Keeffe credit for reinvigorating the field of modernism and for feminizing its "styles" through her "sensitized line."[98] But as these types of descriptions began to accrue in the early 1920s, O'Keeffe would require a male counterpart to round out and fulfill the desired biological equation — or so the critics would have it in their development of a narrative to explain the unique traits of American modernism and a trajectory separate from that of Paris. This, in part, is where Dove would come in. He would help to reweave this history, to make it cohesive, his masculine voice providing an obligatory critical analogue and parallel.

In his early take on O'Keeffe and her imagery, Tyrrell had alluded to a romantic duality of "'two lives' . . . distinct yet invisibly joined," tacitly suggesting that her work could not be considered on its own, apart from a male equivalent.[99] For all of his willful disbelief as to the possibility of O'Keeffe putting forward an independent aesthetic stance and achieving a rethinking of modernism, Tyrrell did concede that her painting was "one with the impulse of an age occupied with eager inquiry and unrest."[100] He allowed that she epitomized a turbulent culture desirous of change, especially given the professional imbalances that women faced, as well as their ongoing

FIG. 40

Georgia O'Keeffe, *Morning
Sky*, 1916. Watercolor on
paper, 8 7/8 x 12 in. (22.5 x
30.5 cm). Whitney Museum
of American Art, New York.
Purchase, with funds from
The Lauder Foundation —
Leonard and Evelyn Lauder
Fund, Gilbert and Ann
Maurer and the Drawing
Committee

BBL 132

muting and repression. (It is significant that O'Keeffe's work emerged in
the late stages of the suffrage movement. Women gained the right to vote
in the United States in 1920, almost three decades before women could
vote in France. After O'Keeffe left the Art Students League in 1914, her cor-
respondence with Pollitzer became filled with references to the suffrage
parades and lectures that they both attended in various cities. O'Keeffe's
position on art was entwined with what she called a "woman's feeling."[101]
Yet, as she later made clear, "I am interested in the oppression of women of
all classes . . . though not nearly so definitely and so consistently as I am in
the abstractions of painting. But one has affected the other. . . . Before I put
a brush to a canvas I question, 'Is this mine? Is it all intrinsically of myself?
Is it influenced by some idea or some photograph of an idea which I have
acquired from some man?'"[102]) However, when Stieglitz took up with O'Keeffe
in mid-1918 and she relinquished her teaching position in Texas to work
full-time as an artist in New York, this union of "two lives" was played out
as a Pygmalion myth. As in the play of that title that the Irish writer George
Bernard Shaw had updated and popularized in 1913, the man — in this case,
Stieglitz — was the dominant factor.

On the eve of O'Keeffe's departure from Canyon, Texas, Stieglitz wrote
to Arthur Jerome Eddy that her work was that of "a remarkable young
woman,"[103] a declaration that acknowledged their considerable difference
in age (he was twenty-three years older), as well as his professional and
economic advantage. When they became immersed in a romantic relation-
ship later that spring, he wrote to Dove with considerably more euphoria,
"O'Keeffe is truly magnificent. And a child at that. — We are at least 90%
alike — she a purer form of myself. — the 10% difference is really perhaps

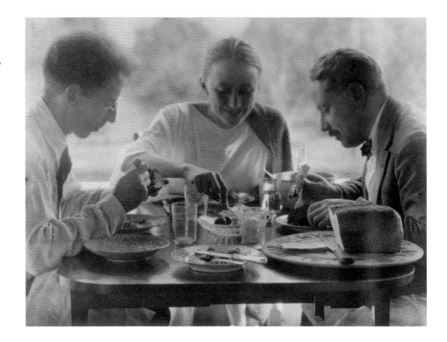

a too liberal estimate. . . . I was glad you met her as you and she did. — She
goes to 291 little."[104] (Although 291 had closed in 1917, Stieglitz kept an office
in the building where the exhibition spaces were once located.) Over the
course of their first summer at the Stieglitz family home on Lake George in
upstate New York, the "10% difference" would dissolve, rendering their fusion
seamless and complete. As Stieglitz continued to effuse to Dove, "O'Keeffe
& I are One in a real sense." He also exclaimed in the same letter of mid-
August 1918 that she was like "Nature itself,"[105] that is, mysterious and not
entirely knowable, establishing her feminine role within a binary relation-
ship predicated upon mutual dependence, but one in which she ultimately
deferred to Stieglitz's orchestration.

There were other friends besides Dove who would meet O'Keeffe soon
after she entered Stieglitz's life and redirected his professional focus (fig. 41).
Paul Rosenfeld quickly became integrated into their social and intellectual
network, conveying to Stieglitz that O'Keeffe's watercolors, in particular,
stood out for their immediacy, that they had instantaneously become etched
in his memory. After seeing her work, he made a bold declaration: "I can call
up dozens of her watercolors with more freshness than I can the 'Bacchus
and Ariadne' of Titian, reproductions of which I saw all my life, and which I
used to admire for hours in the National Gallery."[106] Putting aside his hyper-
bole and his wild boasting about the prowess of American modernism, it was
in large part Rosenfeld who loaded the critical rhetoric about O'Keeffe with
romantic content, steering its descriptions beyond any formal analysis.

Stieglitz had been forced to close 291 in 1917; the war and his wife's
depleted financial resources had impacted his treasured space, leaving an
emotional void that would be filled by O'Keeffe. Her presence in his world

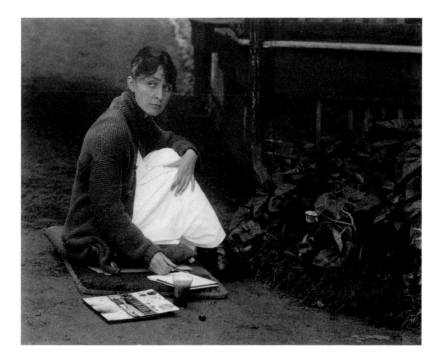

FIG. 42

Alfred Stieglitz, *Georgia
O'Keeffe at Lake George,
August 1918*, 1918. Gelatin
silver print, 3⅝ x 4⅝ in.
(9.2 x 11.7 cm).
Baltimore Museum of Art.
Gift of Cary Ross

partially made up for this deficit, freeing him to devote increased time to his photography (fig. 42), a creative outlet that had suffered during his consuming crusade for the painters who had dominated his programming since 1908. Yet when it came to any long-lasting pairing, it was O'Keeffe and Dove who would eventually be molded to fit Henry Tyrrell's — ergo, Stieglitz's — dictum of "two lives" in order to fulfill the prophecy of American modernism. Photography could never fit this bill: its diminished status remained a drawback and a perennial issue until the late 1940s.

Stieglitz embarked on a series of mostly erotic photographs of O'Keeffe's body soon after they met. He was obsessed with the correspondences between her naked frame and the landscape, dwelling on their similar undulations, curvatures, folds, and hidden interior spaces (fig. 43). More than transparent declarations of his renewed potency as a lover, these sexualized takes became an extension of his comeback as a photographer and dealer, an assertion of his authority and ability to express rejuvenation at a time when Marius de Zayas and his Modern Gallery had begun to decline. De Zayas had not been able to sustain any momentum as Stieglitz's successor, let alone build on the formalist notions of purity that he and Willard Huntington Wright had seeded within modernist American criticism. In 1921, de Zayas vacated his business and relocated to Spain.

Many of Steiglitz's photographs of O'Keeffe were exhibited at the Anderson Galleries in 1921 as part of a sweeping retrospective of his work. It comprised 145 images and was the first such overview in eight years. (A previous survey had been mounted at 291 in 1913 to coincide with the Armory Show, another gesture on Stieglitz's part to consolidate his pioneering stake

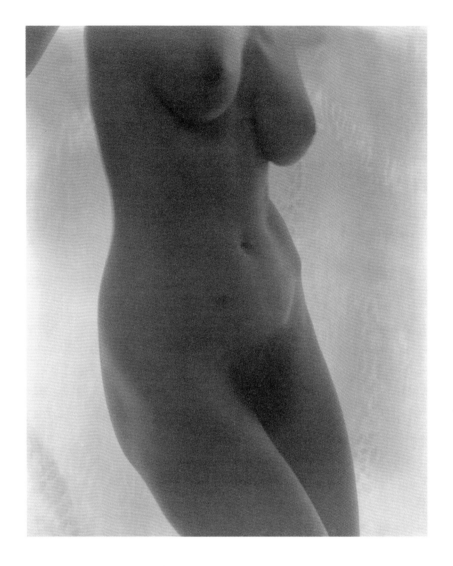

in the New York art world.) While the photographs of O'Keeffe became tropes
for his renewed vigor and ongoing performance as one of the foremost artists
in the United States, the photographic references to O'Keeffe were imper-
sonal and anonymous. Her face was conspicuously cropped in images that
focused on her torso, hands, and breasts, all of which rendered her as a
fragmented object, occluding any specificity to their relationship, not to men-
tion her subjectivity and her creative identity as a painter. Henry McBride
(1867–1962), who wrote for both the *New York Herald* and the *New York Sun*
in the early 1920s, in addition to the *Dial*, noted later that this installation
"made a stir. . . . Mona Lisa got but one portrait of herself worth talking
about. O'Keeffe got a hundred. It put her at once on the map. Everybody knew
the name. She became what is known as a newspaper personality."[107] The
project emerged as something of a comeback for Stieglitz after the demise
of 291, engendering widespread discussion. As McBride wrote in his review
of the show, "[T]here had been so much private conjecture, but greater than
the photographs was Alfred, and greater than Alfred was his talk — as copi-
ous, continuous and revolutionary as ever."[108] Thereafter, Mitchell Kennerley

(1878–1950), who ran the Anderson Galleries and who had staged the *Forum Exhibition* in 1916, made his spaces available to Stieglitz to mount a number of exhibitions before Stieglitz reestablished his programming in 1925 with the Intimate Gallery, a small room within the Anderson Galleries that would prefigure his last, more commodious establishment: An American Place, which opened in 1929 and operated until 1950.

The appearance, let alone the sensation, of O'Keeffe's body within this 1921 exhibition led to her considerable feelings of vulnerability, as well as a confused desire to remain both visibly part of the hype and at the same time anonymous. In a special issue of *MSS*—a short-lived publication launched with Stieglitz's coaxing by Paul Rosenfeld and Herbert J. Seligmann (1891–1984; fig. 44), a journalist and writer who contributed to the *New Republic*, among other publications—O'Keeffe allowed, "I have been much photographed." Yet her terse acknowledgment of exposure was accompanied by a contradictory polemical disclaimer: "I paint because color is a significant language to me but I do not like pictures and I do not like exhibitions of pictures. However I am very much interested in them."[109] The issue of *MSS* that contained O'Keeffe's offhand remarks was devoted to the question "Can a Photograph Have the Significance of Art?" a theme patently orchestrated to reevaluate the standing of the medium after Stieglitz's retrospective, assuming that the moment was once again ripe to argue for the place of

FIG. 44
Alfred Stieglitz, *Herbert J. Seligmann*, 1921. Palladium print, 9⁵⁄₁₆ x 7⁷⁄₁₆ in. (23.7 x 18.9 cm). National Gallery of Art, Washington, D.C. Alfred Stieglitz Collection

photography within the prevailing aesthetic canon and that its commercial applications, moreover, had become increasingly inconsequential and secondary. O'Keeffe's mention of color as her chosen métier was tossed out as a means of differentiating her work, not as a rebuke of or judgment on photography, whatever her misgivings about its ennobling of her nude figure (and about the public disclosure of her intimacy with Stieglitz). She knew that Stieglitz had aimed for something higher than illustration in his work, that his "pictures" should be assessed for their radical content. Nevertheless, uncertainties as to their status as art persisted for another two decades in much of the mainstream press, which continued to build on the entrenched biases against the medium within museum culture.

For example, Thomas Craven (1888–1969), who had submitted a ponderous, stilted contribution to the special *MSS* issue, was not entirely convinced that photography should be aggrandized, let alone privileged through discussion in an intellectual forum. Later, in the *Nation,* he would write on Stieglitz's *Equivalents* (fig. 45), the series of cloud formations that were stand-ins for

the variability of his emotional life, images he had embarked upon soon after his show at the Anderson Galleries closed. Here Craven was even more disdainful of their grace and their emboldened attempts to draw comparisons with painting. Stieglitz, he asserted, was "probably the most accomplished photographer in the world, [yet he] shares the delusions of the laborious old botanical copyists. He asks us to believe that the reduplication of natural phenomena carries an emotional freightage identical with that of creative art; that the transfers of his camera are as intense and exciting as the canvases of imaginative painters whose forms are not the result of simple impressions but the product of knowledge, reflection, and a genius for construction."[110] Stieglitz was aware that "photography . . . [was] still 'on trial,'"[111] that even such progressive publications as the *Nation* would be slow to recognize its value, that a mind such as Craven's, which was invested in tradition and maintaining its stability through an ongoing reworking of the figure in painting, would momentarily prevail. Significantly, the Museum of Modern Art began to collect photographs shortly after its founding in 1929, yet a department devoted to the medium would not be established until 1940.

With the onset of the Great Depression, Craven would impose a critical sanction on all facets of modernism, including painting, fixating on its perceived self-absorption while maintaining that with the "bleak realities of life — a cruel blow [was dealt] to those who, in the sunny days of speculation and unearned incomes, used to tell us that art pursues its own sweet way, independent of the sordid affairs of mankind."[112] Stieglitz was Craven's primary target. Craven's animus was directed toward Stieglitz's conception of American authenticity; he believed that the artists Stieglitz exhibited — with the salient exception of Marin and O'Keeffe — were promoting a pale adaptation of Cubism, beholden as they were to its radical excesses and inventive direction. In short, Craven felt that better examples of an American ethos could be found in the work of his old friend Thomas Hart Benton (1889–1975), whose conscious revival of known episodes in national history was first realized in his uncommissioned series of murals, *The American Historical Epic* (1919–26), which purposely avoided Paris and revived the visual syntax of Michelangelo.[113]

Whatever the talk surrounding Stieglitz's exhibition at the Anderson Galleries in 1921, as the critical discourses that related to the propriety of American art and its subjects multiplied, the implications of Stieglitz's relationship with O'Keeffe and their joint engagement of the evanescence of nature, along with its potential to act as a surrogate for feeling and intuition, would be skirted and sidestepped, never fully excavated by writers during their lifetime.[114] Yet these charged overtones would not be wasted. While Stieglitz recognized that photography still awaited its match with painting

(fig. 46), critics such as Rosenfeld would run with the opportunity to extract
meaning from this male/female dualism and to apply it to American modern-
ism. In the wake of the critical reception that accompanied Stieglitz's 1921
retrospective, Rosenfeld wrote not only on Dove's "virile and profound tal-
ent" but on his "complement" in O'Keeffe, one that he thought was revealed
through "the woman polarizing herself, accepting fully the nature long denied,
spiritualizing her sex. Her art," he affirmed, "is gloriously female."[115]

For the male half of the equation, Rosenfeld suggested John Marin,
an artist who had been incorporated into Stieglitz's program at 291 in 1909,
but as Rosenfeld's argument escalated, his discussion of Marin's masculin-
ity waned, since Marin's imagery never fully referenced the carnal aspects
of the body. His landscapes and skylines were perpetually abstracted as
networks of lines or washes of color that retained some lingering acknowl-
edgment of the legacies of Cubism and made few references to the figure.[116]
Rosenfeld had not been alone in pinpointing the "female" dimensions of

O'Keeffe's art and, by extension, the male corollary. Henry Tyrrell, after all, had posited the idea of "two lives" in his review of her show at 291. A few years later, moreover, Marsden Hartley extrapolated from Tyrrell's gendered reading to proclaim more brazenly that O'Keeffe's work represented "living and shameless private documents . . . tempered to abstraction by the too vicarious experience with actual life. . . . She is one of the exceptional girls of the world both in art and in life."[117] Hartley, however, saw no reason to align O'Keeffe with a male counterpart. He believed that her painting stood on its own, that its ineffable "purity" was enough to justify both its novelty and its worth.[118] In Hartley's ecstatic estimation, O'Keeffe's painting was well situated to navigate the crucibles of the press. He never considered that his own analysis would add to her unease and humiliation.

Paul Rosenfeld was the first writer to construct a sexual dichotomy that explicitly accounted for the advent of O'Keeffe within American modernism, as he sensed that she required both an appendage and the weight of patriarchy to fully explain paintings such as *Blue Line* (fig. 47) and *Red & Orange Streak* (plate 22), both from 1919, in which the landscape was rephrased as a sensuous, vibrant mechanism while its features were reduced to a few evocative, abstract shapes, alternatively curved and rectilinear. As Rosenfeld saw it, these intrepid compositions built on the history of modernism but had few American precedents: there was only one artist with whom O'Keeffe could legitimately be paired, and that was Arthur Dove. Ironically, Rosenfeld's ruminations on their coupling took place as he traveled abroad with Sherwood Anderson and his wife, a few months before he wrote his piece for the *Dial*. In a letter Rosenfeld wrote to Stieglitz in the summer of 1921 he mused, "[T]raveling of this sort, then, I suppose is of very little value. How do I do it? That's a great question for me. I wonder whether there is any country or place does this sort of work for you? Certainly, Paris doesn't. What Paris gives you, it seems to me, is mostly the beauty of the past."[119] This trip provided fodder for Rosenfeld to strike further contrasts with American art and culture. As he assessed what he considered to be the "weakness" of contemporary French painting, he continued to alight on Dove, again writing to Stieglitz from Paris, "I have thought a good deal about him this summer, and came to the conclusion I don't know why that he's the strongest thing we have."[120] But his adulation came with a disclaimer: he worried that Dove's conflicted relationship with his father, combined with his work as an illustrator, would overwhelm his prospects to become America's foremost painter. Rosenfeld's anxieties soon dissipated, however. Dove's father died in June 1921, and a few months later, Dove left his life in Westport to take up with Helen Torr, the act that would result in his renewed commitment to painting.

The Dove/O'Keeffe alliance that Rosenfeld forged in "American

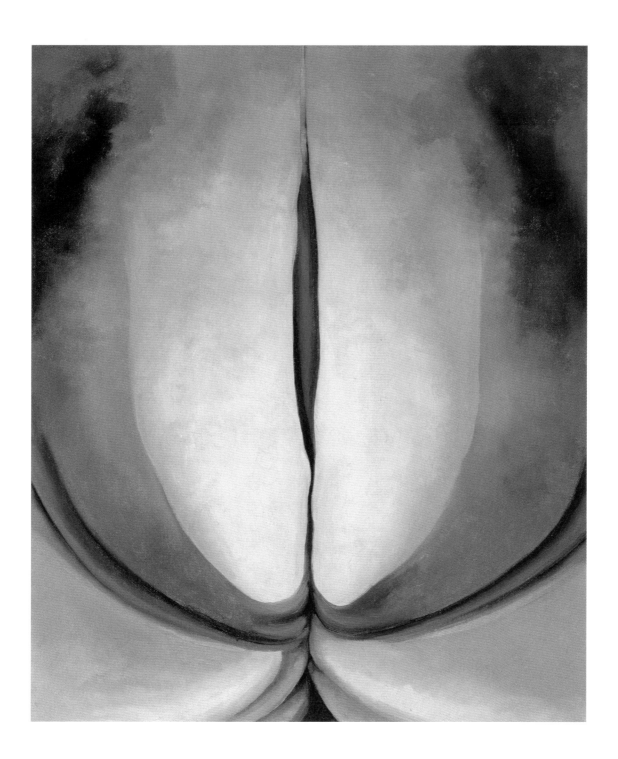

Painting," his essay for the *Dial*, would redound in numerous subsequent comparisons. It became an emblem of the uniqueness and vigor of American art, as well as of the culture's new relaxed sexual mores. Sherwood Anderson later remarked that America had eased up on the issue of gender equality. Not only had women just achieved the right to vote, but, he observed, "[a] kind of healthy new frankness was in the talk between men and women, at least an admission that we were all at times torn and harried by the same lusts."[121] Anderson and Rosenfeld had no doubt discussed this new openness on their trip to Paris as they delineated that city's contrasts with New York,

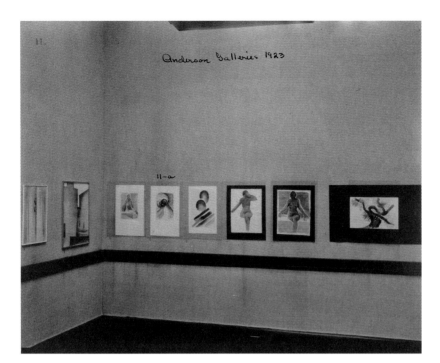

FIG. 48

Photographer unknown,
*"Alfred Stieglitz Presents
One Hundred Pictures:
Oils, Watercolors, Pastels,
Drawings by Georgia
O'Keeffe" installation at the
Anderson Galleries, New York,
January 29–February 10,
1923*, 1923. Whitney Museum
of American Art Library
Archives, New York

providing additional justification for Rosenfeld's notion of a male/female dualism, at least when it came to art. Despite the relaxation of gendered social strictures, O'Keeffe felt demeaned by any discussion of her sexuality. As she confided to Mitchell Kennerley in the fall of 1922, on the eve of her one-person exhibition at the Anderson Galleries the following January (fig. 48), another project that had been orchestrated by Stieglitz, "[I]t embarrassed me — You see Rosenfeld's articles have embarrassed me — I wanted to lose the one for the Hartley book. . . . They make me seem like some strange unearthly sort of a creature floating in the air — breathing in clouds for nourishment — when the truth is that I like beef steak — and like it rare at that."[122] The assertion that O'Keeffe was not an otherworldly object was fraught, revealing a fragility that would last until Stieglitz's death in 1946, when she would gain more control over her professional life.

O'Keeffe's 1923 show — comprised of one hundred images such as *Blue and Green Music* (fig. 49), *Blue Line* (see fig. 47), and *Lake George with Crows* (plate 30) — represented a large, unwieldy survey of her work that revealed her vacillating pictorial interests: she could be seen both rendering nature as an abstract structure (and highlighting its parallels to music) and mining it for its recognizable landscape elements. O'Keeffe may have been uneasy about the show, but she agreed to it, stating, "I say that I do not want to have this exhibition because, among other reasons, there are so many exhibitions that it seems ridiculous for me to add to the mess, but I guess I'm lying." She admitted, "I probably do want to see my things hang on a wall as other things hang so as to be able to place them in my mind in relation to other things I have seen done."[123]

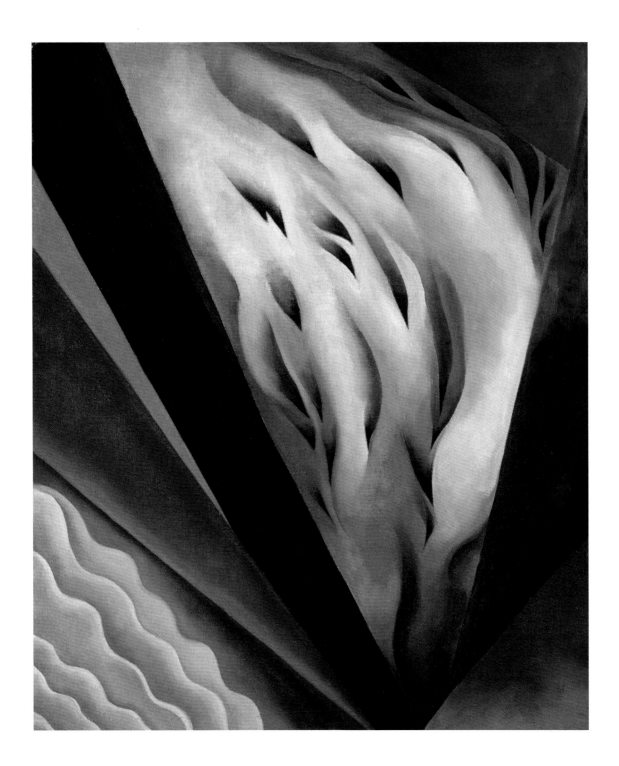

FIG. 49

Georgia O'Keeffe, *Blue and Green Music*, 1921.
Oil on canvas, 23 x 19 in.
(58.4 x 48.3 cm). The Art
Institute of Chicago.
Alfred Stieglitz Collection,
Gift of Georgia O'Keeffe
BBL 344

Rosenfeld's 1921 essay "American Painting" reopened the discussion about American modernism. There were some figures in New York, such as Thomas Hart Benton, who contended that Rosenfeld's article enacted Stieglitz's views, that it retained little independence from their conversations regarding the evolving definitions of an indigenous art. Benton wrote to Stieglitz immediately after the piece appeared in print: "I read Rosenfeld's article in the Dial. As that part of it which relates to the younger painters is so patently a reflection of your opinion I write to you rather than Rosenfeld."[124] Benton had his misgivings about Stieglitz's crusade for American modernism, feeling blunted and rejected by Stieglitz's program at 291, where he had never shown his work, and his insinuation that Rosenfeld was incapable of original thinking, too enthralled with New York's first booster of modernism, was widely circulated. After all, Rosenfeld had written to Stieglitz in mid-1920, as he continued to formulate his case for the separate trajectory of contemporary American art, proclaiming, "I don't know why it has not occurred to me sooner that you are the only great artist U.S.A. had produced since Walt Whitman, Henry Adams not withstanding."[125] Benton, among others, had picked up on Rosenfeld's overly deferential relationship with Stieglitz. But Rosenfeld was motivated by desires beyond mere reverence. The issue of supplanting a burgeoning formalist discourse was also at stake. In short, once Marius de Zayas gave up on his Modern Gallery in 1921, Rosenfeld saw the opportunity to redirect American art criticism, stating in a letter to Stieglitz that the "confidence-effect in de Zayas" had resulted in too many setbacks and had hindered the meanings of American art by mixing its histories with those of Europe — and with the growing influence of formalist writings, such as those by Clive Bell.[126] Stieglitz had been interested in Bell since the mid-1910s, recommending Bell's work to O'Keeffe while she still resided in Texas. In 1922, Stieglitz wrote to Dove, "I've been reading Clive Bell's 'Since Cézanne,' short essays published in magazines during the last few years. I had seen them but in book form they make amusing reading. — Easy reading. — And he says some good things. — It's not a heavyweight affair but worthwhile nevertheless."[127] His qualified endorsement of Bell's work as an analytic tool was telling, revealing both hesitancy and enthusiasm. Stieglitz had clearly pondered the application of Bell's premise of "significant form" to the work of such artists as Dove, O'Keeffe, Marin, and Hartley, wondering if it could account for its subjects and accompanying meanings. Moreover, in one of his letters to Dove during the summer of 1922, Stieglitz noted Guillaume Apollinaire's "Aesthetic Meditations on the Cubist Painters," which had just been translated into English and published in the Little Review (a New York–based quarterly of art and literature that thrived until 1929). Dove, too, responded to the "plastic virtues" in the French poet's piece[128] and to his

proposition that "purity, unity and truth, hold nature downed beneath their feet," as well as his emphasis on invention and compositional clarity.[129]

Yet, in a reverse on the influence that Stieglitz wielded over Rosenfeld, after reading the manuscript for Rosenfeld's book *Port of New York: Essays on Fourteen American Moderns* — to be published in 1924 with chapters on Dove, Stieglitz, O'Keeffe, Anderson, Marin, and others — Stieglitz wrote:

> Yes, you have struck it — why it's so important: America without that damned French flavor! — It has made me sick all these years. No one respects France [more] than I do. . . . That's why I continued my fight single-handed at 291 — That's why I'm really fighting for Georgia. She is American. . . . So am I. Of course, by American I mean something much more comprehensive than is usually understood — If anything is usually understood at all! Of course the world must be considered as a whole in the final analysis. That's really a platitude. . . . But there is America. — Or, isn't there an America? Are we only a marked down bargain day remnant of Europe? Haven't we any of our own courage in matters "aesthetic"? Well, you are on the true track and there is fun ahead.[130]

While Stieglitz and Dove might have valued the discourses of purity that emanated from abroad, both also knew that American criticism needed to distance itself from these models in order to gain credibility. Dove especially found himself drawn to theories stressing the formal underpinnings of art once he renewed his commitment to the implications of his daring abstractions of 1911–12. Or, as he would later ask about works such as *#4 Creek* (plate 9), *Penetration* (plate 10), and *River Bottom, Silver, Ochre, Carmine, Green* (plate 11), which built on these origins, "[W]hy not make things look like nature? Because I do not consider that important and it is my nature to make them this way. To me it is perfectly natural. They exist in themselves, as an object does in nature."[131] Dove continued, of course, to probe these foreign sources, but the American content in the writing of Rosenfeld and Anderson retained an equal if not paramount significance for him. As American art criticism continued to investigate the singularity of modernism, Dove occasionally appropriated Freudian language, finding it useful, ironically, when it came to defending Georgia O'Keeffe, who had by now become his friend. In one example, Samuel Kootz (1898–1982), a writer who later founded a gallery devoted to the work of Abstract Expressionist painters such as Robert Motherwell (1915–1991) and Hans Hofmann (1880–1966), attempted a formalist take in his *Modern American Painters* of 1930, arguing that "much of [O'Keeffe's] earlier work showed a womanly preoccupation with sex, an uneasy selection of phallic symbols in her flowers, a delight in

their nascent qualities. O'Keeffe was being a woman and only secondarily an artist. Assertion of sex can only impede the talents of an artist."[132] Dove then countered in a letter to Stieglitz, "[T]he bursting of a phallic symbol into white light may be the thing we all need."[133]

Kootz clearly felt that there were other, more meaningful ways to describe American art than using the romantic excesses that character-ized Rosenfeld's prose, not to mention Rosenfeld's patent nationalism. Dove enthused about Kootz's book, "It would take quite a man to do a better book. Many things happen in it which make it live."[134] He was no doubt relieved to find some modicum of analysis in Kootz's stab at a synthesis of Ameri-can modernism, one that unified art through compositional ingenuity. Yet he remained put off by Kootz's stereotyping in his uneasy assessment of O'Keeffe, where, despite the empiricist aims of his book, she was written off as a mar-ginal artist. Dove lamented to Stieglitz that Kootz "justly criticizes the *sexless* thinking of the men painters of this country and then proceeds to demand *less sex* of the woman O'Keeffe."[135] Although Kootz had bristled at Rosenfeld's pseudo-psychology, he was initially seduced by the same metaphors, though for Kootz sex was a limitation rather than an asset, interfering with the more serious business of elucidating the inherent traits of painting.

There had been no place for any mention of Apollinaire's "plastic vir-tues" in Rosenfeld's texts. The construct was too aligned for him with Paris and its contemporary spin-offs of Cubism, as well as too uncompromising in its focus on the internal constituents of painting. In response to Stieglitz's effusive comments on his draft for *Port of New York*, Rosenfeld wrote, "[T]he fight against provincialism in America is the crucial one. We do all sorts of stupid things principally because we have no respect for ourselves as Americans. I am sick of foreign reputations and France-worship."[136] Once Rosenfeld's book was published, references to the sexualized traits that he contended set American art apart would abound, so overloaded in his own writing that his descriptions of Dove and O'Keeffe seemed to impute a real-life partnership rather than an imagined one. (For the record, there was no such romance or hidden affair.) In his earlier essay "American Painting," Rosenfeld had expanded that "if [this] artist [Dove] instance[s] in [his] work the unification of the male, the oils, water-colors, and black and whites of Georgia O'Keeffe instance the complement. . . . Her art is gloriously female. Her great painful and ecstatic climaxes make us at last to know something the man has always wanted to know. For here . . . there is registered the manner of perception anchored in the constitution of the woman. The organs that differentiate the sex speak."[137] In *Port of New York*, Rosenfeld extended such declarations, making them part of a binary distinction that served to promote his at times grandiloquent nationalism. There Rosenfeld asserted,

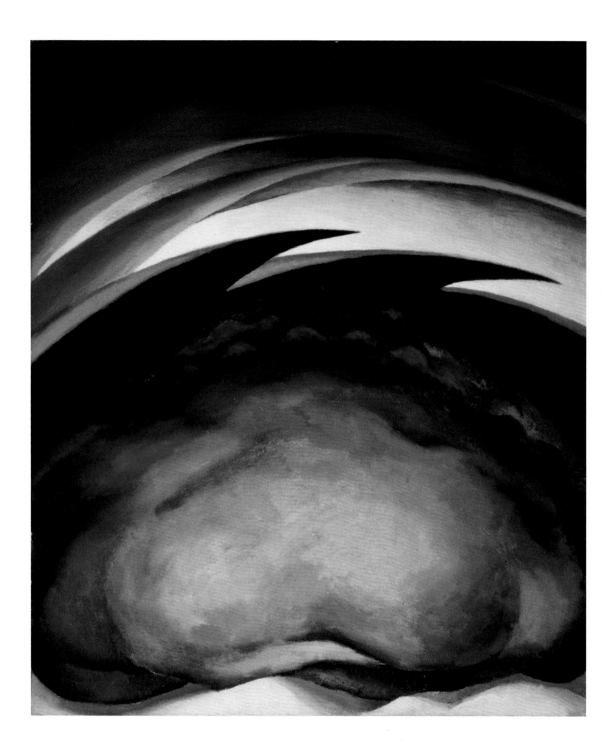

FIG. 50

Georgia O'Keeffe, *Series I—
From the Plains*, 1919. Oil on
canvas, 27 x 23 in. (68.6 x
58.4 cm). Georgia O'Keeffe
Museum, Santa Fe, New
Mexico. Promised gift, The
Burnett Foundation
BBL 288

"For Dove is very directly the man in painting, precisely as Georgia O'Keeffe is
the female; neither type has been known in quite the degree of purity before.
Dove's manner of uniting with his subject matter manifests the mechanism
proper to his sex as simply as O'Keeffe's methods manifests the mechanism
proper to her own."[138]

Despite its hyper-magnification of the gendered body, Rosenfeld's
alignment of Dove and O'Keeffe was a natural aesthetic connection. While it
made for provocative copy, spilling into and influencing subsequent descrip-
tions of the artists, such as Waldo Frank's focus on the "full . . . loamy

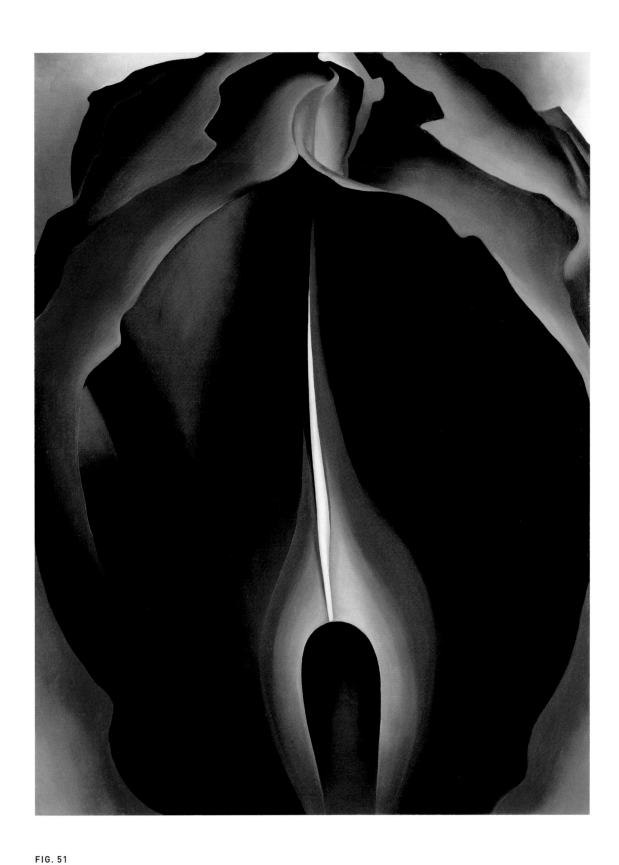

FIG. 51

Georgia O'Keeffe, *Jack-in-the-Pulpit No. IV*, 1930.

Oil on canvas, 40 x 30 in. (101.6 x 76.2 cm).

National Gallery of Art, Washington, D.C.

Alfred Stieglitz Collection, Bequest of Georgia O'Keeffe

BBL 718

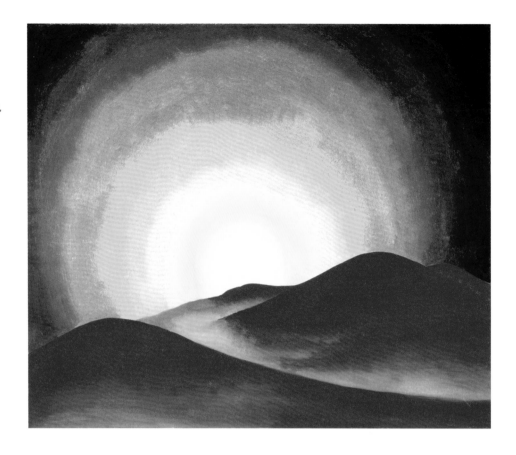

hungers of [O'Keeffe's] flesh," or an account by Oscar Bluemner (1867–1938) of O'Keeffe's "painter's vision [which was] new, fascinating, virgin American,"[139] the work of each artist had palpable correspondences. These could be read not only in paintings such as O'Keeffe's *Series I — From the Plains* (fig. 50) and Dove's *Thunderstorm* (plate 28), where prominent, abstract serrated outlines forge concrete pictorial relationships that suggest Dove had begun to study carefully the work of his erstwhile acolyte, but in numerous later pairings as well. O'Keeffe's *City Night* (plate 14) and Dove's *Silver Tanks and Moon* (plate 15), for example, make use of the same compositional format, with their phallic thrust of architectural forms illuminated by the glow of a full moon. Her *Jack-in-the-Pulpit No. VI* (plate 57) and his *Moon* (plate 58) provide the same comparisons: in each painting, the reduction of a natural shape is elided into a suggestive gendered form, with allusions to the male genitalia conspicuous rather than hidden, emerging as part of an unbridled exhalation of the profundity of nature. (See also her *Jack-in-the-Pulpit No. IV* [fig. 51] and *Jack-in-Pulpit — No. 2* [plate 56].) Similarly, references to the sun and the moon and their diurnal rotations abound in many of both artists' paintings, informing an overlapping, common visual lexicon (fig. 52).[140]

There were other American modernist artists, such as Marin (fig. 53), Bluemner (fig. 54), and Charles Burchfield (1893–1967), who also would tie their scenes of the city and landscape to a dominant, luminous orb. Unlike

these painters, Stieglitz had suffused his *Songs of the Sky* and *Equivalents* with a sensual wash of light that often masked its source, and the cloud was nearly always the more prevailing compositional element in his photographs. Sherwood Anderson identified a certain "maleness" in Stieglitz's work, which, he effused, had "something to do with the craftsman's love of his tools and his materials," implying that the phallic lens of the camera could insinuate itself into this sexualized argument.[141] However, the work of Dove and O'Keeffe, as Rosenfeld had made clear, revealed more discernable evidence of merging their bodies with nature, of locating images within its topography that could adumbrate their exhilaration about both modernism and the landscape.

Some of these images were fueled by discussion and debate among the artists. For instance, Dove painted *Penetration* at Anderson's request after he saw Dove's *#4 Creek* and told a contemporary, "[H]e drew it while knee-deep in flowing water, looking downstream into the woods; but his friends called it *Penetration* — which came nearer to his intention." Within the tight circle of Stieglitz's associates who congregated in places such as Westport, Manhattan, and Lake George, these sexualized interpretations were privately tested and circulated, part of an intimate dialogue among friends. While O'Keeffe was embarrassed by the erotic accounts of her work, many of her paintings — even those of the built environment, such as *New York with Moon* (plate 16), *The Shelton with Sunspots, N.Y.* (fig. 55), and *Radiator Bldg — Night, New York* (fig. 56), subjects that she hoped would neutralize these descriptions — resulted in furthering, if not escalating, her sexualization by many writers.[143]

As Rosenfeld was at work on *Port of New York*, Stieglitz added to his trope of the symbiosis of Dove and O'Keeffe in 1923 when he wrote to Sheldon Cheney (1886–1980), who was planning a book to be titled *A Primer of Modern Art*, that "Dove about 6 years ago, when he saw O'Keeffes watercolors at '291' said to me: 'This girl . . . is doing what we fellows are trying to do. I'd rather have one of her watercolors than anything I know.'" He closed his letter by stating, "Dove understands O'Keeffe's work. Hers & his are related."[144] Dove never acquired one of O'Keeffe's watercolors, but he did purchase *Abstraction* (plate 33), a small painting from 1919 that was exhibited at the Anderson Galleries in 1923. In fact, he and Torr hung the work on the *Mona*, the forty-two-foot boat that served as their primary domicile until the 1930s as they moored at such various sites as Noroton, Halesite, Port Washington, and Huntington Harbor on Long Island Sound (figs. 57 and 58). Dove wrote to Stieglitz soon after acquiring *Abstraction*, "The O'Keeffe painting looks better than ever, especially in the boat here by the light of our lantern."[145] While the correlations between this work and his own remained generalized, as Dove

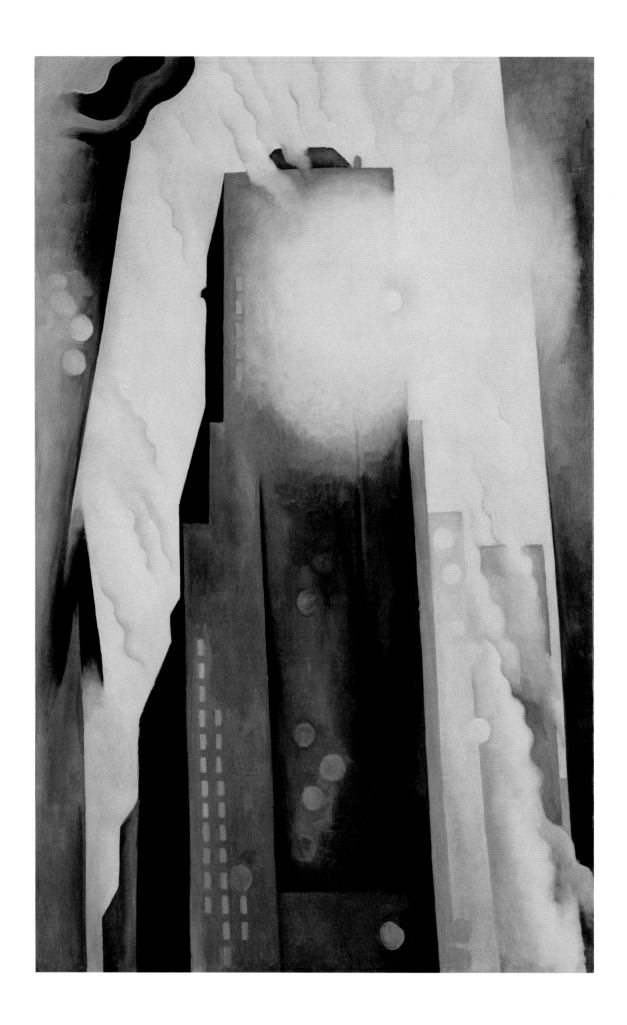

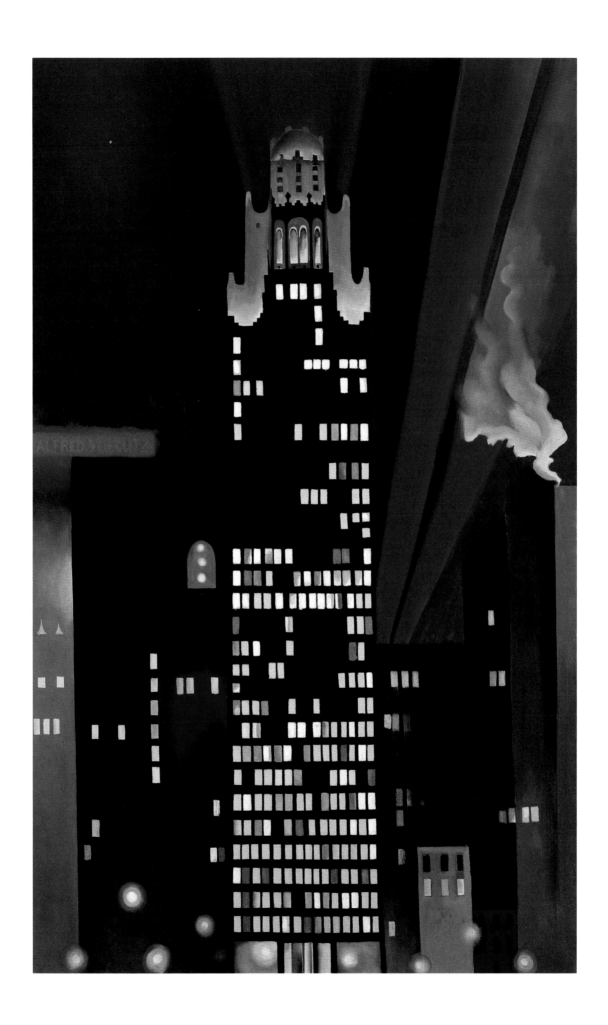

rarely introduced geometry into his own abstractions, the painting was clearly a symbolic object, evidence not only of the new prowess of American art but of O'Keeffe's ability to extend the pictorial parameters of modernism.

Dove had given Stieglitz and O'Keeffe his pastel *Cow* (fig. 59) soon after their union in 1918. Stieglitz then conveyed to Dove, along with his new rhapsody about O'Keeffe, "You don't know what the 'Cow' meant to O'K. & me. — It outlived virtually everything else we had about us. — We often talk of it."[146] This pastel had grown out of the series that included *Leaf Forms and Spaces*, the work in Arthur Jerome Eddy's volume to which O'Keeffe was initially drawn. Independent of Stieglitz, she later acquired Dove's *Rain* (plate 34), a whimsical collage from 1924 that she lived with at the apartment that she shared with Stieglitz in New York and afterward installed in Abiquiu along with Dove's 1937 painting *Golden Sun* (plate 38). In her 1962 interview with Katharine Kuh, she would stress the centrality of these works by Dove: "My house in Abiquiu is pretty empty; only what I need is in it. I like walls empty. I've only left up two Arthur Doves, some African sculpture and a little of my own stuff."[147] Midway through the 1930s, she also purchased six water-colors by Dove (only one of whose whereabouts is currently known).[148] Her purchase of these "self-portraits," as Dove referred to them, or revelations of his interior life, continued the symmetry of their mutual enthusiasm for each other's work.[149]

FIG. 57

Mona, the sailboat on which Arthur Dove and Helen Torr lived in the 1920s.
The Estate of Arthur Dove

FIG. 58

Arthur Dove, late 1920s.
The Estate of Arthur Dove

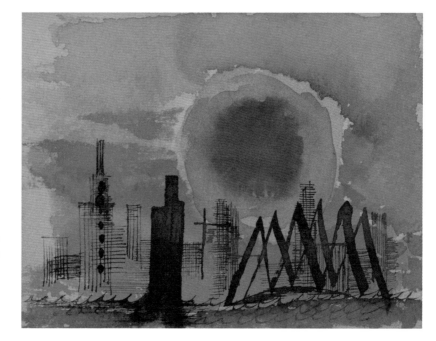

FIG. 59
Arthur Dove, *Cow*, 1914.
Pastel on canvas, 17¾ x
21½ in. (45.1 x 54.6 cm). The
Metropolitan Museum of Art,
New York. Alfred Stieglitz
Collection, 1949 (49.70.72)
ALM 12/13.3

FIG. 60
Arthur Dove, *Untitled*,
c. 1930. Watercolor on paper,
3⅛ x 4 in. (8 x 10 cm). Arthur
and Helen Torr Dove Papers,
1905–1974, Archives of
American Art, Smithsonian
Institution, Washington, D.C.

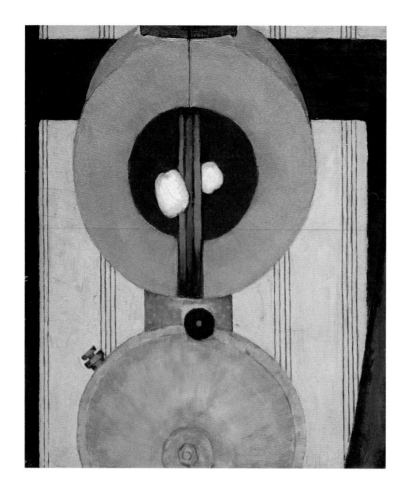

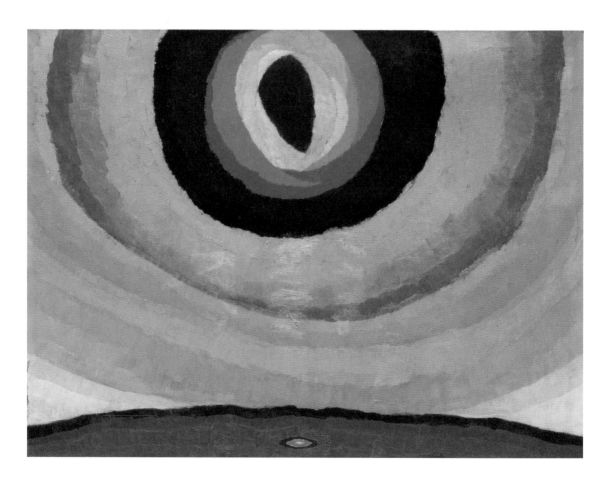

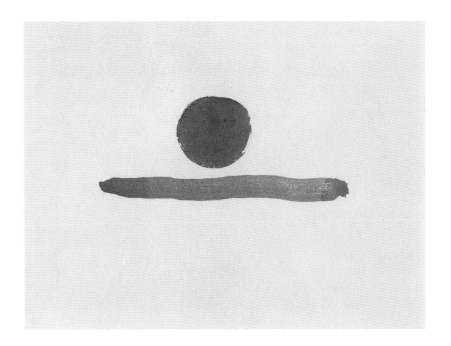

Dove had taken up the medium of watercolor around 1930 (fig. 60; see also plates 45–48), just as he wrote a statement for Kootz's *Modern American Painters* in which he retrospectively assessed his work of the 1910s. He averred that his primary ambition at the time had been to depict the inner radiance of all natural things, the elusive palette of the outdoors and its changeable colors — what he called "a condition of light." But as he reflected on this project, O'Keeffe's exhibition of watercolors at 291 in 1917 had intervened and altered his aesthetic thinking. Her "burning watercolors," he concluded, had subsequently changed his painting.[150]

Dove's work did become more luminous in the 1920s. His *Lantern* (fig. 61), *Sea II* (plate 24), and *Silver Sun* (fig. 62) employed resplendent materials and were encased in aluminum or silver-leaf frames, which heightened their metaphysical associations. Although O'Keeffe's work in watercolor became episodic and occasional after 1918 (fig. 63), Dove made more prolific use of the medium, exclaiming to Stieglitz in 1930 that he was "bringing forth one or two a day."[151] Dove would continue this pattern until his death in 1946 (see figs 64 and 65). His "small things," as Stieglitz called them, became a staple of his output.[152] The fluidity of the watercolor process anticipated the immediacy and formal reduction of natural elements in his late paintings, such as *Formation I* (fig. 66) and *High Noon* (fig. 67). Despite certain discrepancies, Dove's and O'Keeffe's imagery became increasingly unified until O'Keeffe left for New Mexico in 1929. As Dove pondered her watercolors such as *Sunrise* (plate 17), *Evening Star No. VI* (plate 19), and *Light Coming on the Plains No. III* (fig. 68), the connections to his painting became more apparent. For instance, O'Keeffe's *Sunrise* had an analogue in Dove's *Sunrise I* of 1936

FIG. 64

Arthur Dove, *Seneca Lake*,
1938. Watercolor on paper,
5 x 7 in. (12.7 x 17.8 cm).
Collection of Judith and
Bruce Eissner

FIG. 65

Arthur Dove, *Lloyd's Harbor*,
1941. Watercolor and
charcoal on paperboard,
12⅛ x 9⅞ in. (30.8 x 25.1 cm).
Amon Carter Museum, Fort
Worth, Texas. Gift of Ruth
Carter Stevenson, 1988.9

FIG. 66

Arthur Dove, *Formation I*,
1943. Oil and wax emulsion
on canvas, 25 x 35 in.
(63.5 x 88.9 cm). San Diego
Museum of Art. Museum
purchase with funds from
the Helen M. Towle Bequest
ALM 43.6; DBB PL. 81

FIG. 67

Arthur Dove, *High Noon*,
1944. Oil and wax emulsion
on linen, 27⅛ x 36¼ in.
(68.9 x 92.1 cm). Wichita
Art Museum, Kansas.
The Roland P. Murdock
Collection
ALM 44.5; DBB FIG. 70

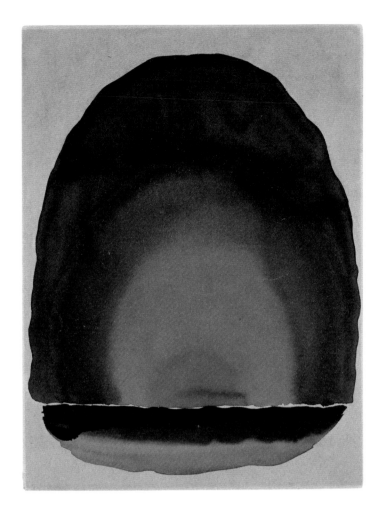

FIG. 68

Georgia O'Keeffe, *Light Coming on the Plains No. III*, 1917. Watercolor on paper, 11⅞ x 8⅞ in. (30.2 x 22.5 cm). Amon Carter Museum, Fort Worth, Texas, 1966.31

BBL 211

FIG. 69

Arthur Dove, *Sunrise III*, 1936. Wax emulsion, oil on canvas, 25 x 35¹⁄₁₆ in. (63.5 x 89.1 cm). Yale University Art Gallery, New Haven, Connecticut. Gift of Katherine S. Dreier to the Collection Société Anonyme

ALM 36.16; DBB PL. 67

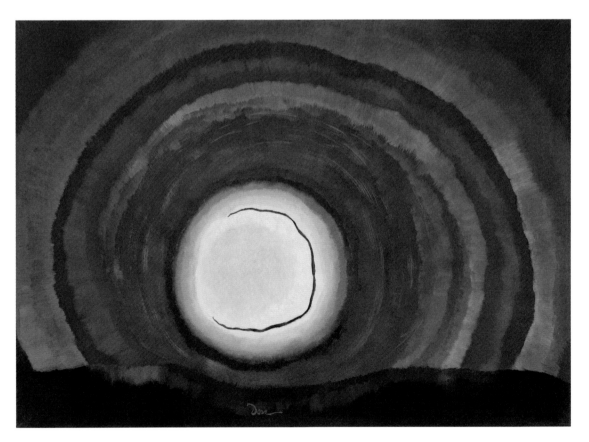

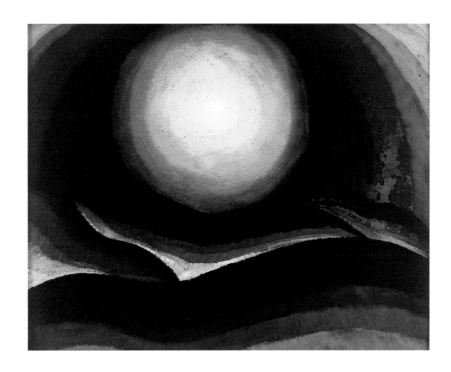

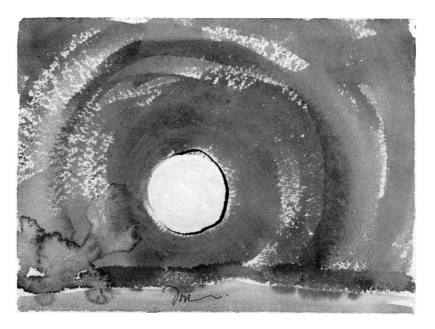

(plate 18), *Sunrise II* (1936; Mr. and Mrs. Meredith J. Long), and *Sunrise III* (fig. 69), as well as *Moon* (fig. 70) and *Sunrise* of 1937 (fig. 71); the rendition of the concentric rays of light in each functions as a conceit. Similarly, Dove's *March, April* of 1929 (plate 36) and *Wednesday, Snow* of 1932 (plate 37) can be allied with O'Keeffe's *The Lawrence Tree* from 1929 (plate 35), in which the marks of light, stars, and drops of snow become both a magical overlay and a lambent device.[153] The comparisons abound further in O'Keeffe's *Dark Iris No. 2* (plate 54) and Dove's *Sea Gull Motive* (plate 55), in which the sensual folds of petals and/or feathers are cast as rippling, abstract patterns.[154]

Rosenfeld's coupling of Dove and O'Keeffe in both "American Painting"

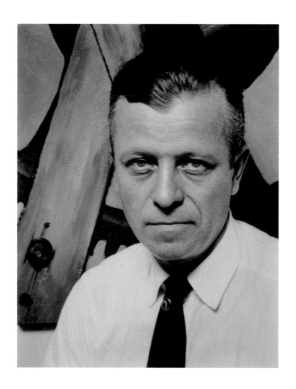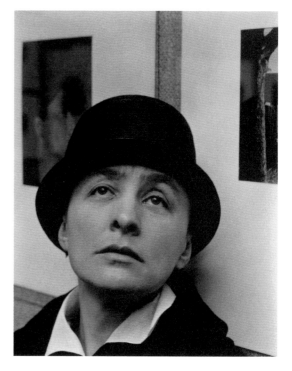

and *Port of New York* would have a profound, albeit momentary, effect on American art criticism as it took up the nuanced and varied territory of modernism. O'Keeffe would always remain conflicted as to the Freudian tack that had resulted in her fame, wanting a more dispassionate, rigorous, and ultimately formalist analysis to account for her originality, whereas Dove knew that Rosenfeld's psychological hook was responsible not only for his comeback as an artist but for the rejuvenated explanations of the authority of American art. Writers such as Waldo Frank and even Edmund Wilson (1895–1972) followed Rosenfeld's lead, the latter reverting to phrases such as "personal heat" to describe the distinguishing features of O'Keeffe's work.[155] Others invoked Rosenfeld's dichotomy while refraining from repeating its sexualized inferences. Henry McBride, for instance, was not tempted by Freud when reviewing *Seven Americans*, another landmark consolidation of Stieglitz's interests at the Anderson Galleries in 1925, which focused on Dove, Hartley, Marin, Strand, O'Keeffe, and Charles Demuth (1883–1935), as well as Stieglitz's own photographs. From his perch at the *New York Sun*, McBride contended that "it is Mr. Dove and Miss O'Keeffe and Mr. Stieglitz who emerge in this exhibition above the heads of the other members of the group. . . . Mr. Dove, due to his years of seclusion, becomes the chief curiosity of the show and rewards it well. It is too much to pretend that his canvases are profound, but they are undoubtedly charming. They are also genuine. . . . Mr. Dove's color is tender, imaginative and lyrical."[156]

Blanche C. Matthias, who covered O'Keeffe's exhibition at Stieglitz's newly formed Intimate Gallery for the *Chicago Evening Post* in 1926, elaborated

on what she perceived to be the handicaps of Rosenfeld's gender-focused pairing. The comparison of Dove and O'Keeffe, she maintained, could yield other, more tangible metaphors relating to the innovative properties and singularity of American painting:

> When Alfred Stieglitz gave O'Keeffe her first exhibition in the then famous, and still remembered gallery known as 291, the result was a terrific bombing directed at the unsuspecting and tranquil artist. The art critics began to study Freud and Jung in an effort to catalog and pigeon-hole a blue-ribboned bundle labeled Georgia O'Keeffe. But somehow she just managed to escape their hastily garnered strength.
>
> Perhaps one reason was that most those whose business it is to understand art and relay it to the public were of the masculine gender, and O'Keeffe's simplicity was profoundly feminine. . . .
>
> A most interesting comparison was possible when Stieglitz placed an Arthur Dove beside an O'Keeffe. Dove's intellect was clearly discerned in the designs and harmonics of his abstract motives. But not, intellect, alone. . . .
>
> Ten years ago Dove was far ahead and he hasn't stopped. The Dove which Stieglitz showed was gray and black, and black-green and brown-black-green. It knew the elements and was unafraid. Madonna-like was the O'Keeffe in related rhythms and purity of conception. The two canvases formed a strangely complete disclosure of nature in unspoiled but sophisticated human translation.[157]

Her anti-Freudian take would induce numerous imitations. C. J. Bulliet (1883–1952), another writer affiliated with the *Chicago Evening Post*, observed that the union of Dove and O'Keeffe was worth retaining, that of all American modernist artists their work grappled most seriously with the abstraction of natural elements: "O'Keeffe has done the best work, perhaps, of any American, male or female, in the pure abstract. . . . Arthur G. Dove, too, revels in the abstract, but without the irresponsible abandon of Georgia O'Keeffe. He can be sensed usually as definitely conscious of form."[158] Such comparisons would continue to linger, with Stieglitz propounding their alliance until shortly before his death in 1946 (a few months in advance of Dove), insisting that they were "two of a kind" (figs. 72 and 73).[159] O'Keeffe, though, deferred to Dove when it came to the heady, intellectual venture of adding to the known languages of art. As he revealed in a prose poem titled "A Different One," written in 1934, "I have heard O'Keeffe say, 'Dove, he's got us beaten.' / There was never any compromise in the introduction of ideas, which had been introduced one after the other for the first time in America."[160]

Coda

When Stieglitz opened his third and final gallery, An American Place (figs. 74 and 75), in 1929 — which focused primarily on the work of Dove, Marin, and O'Keeffe — the critical discourses to which his artists would soon be subjected were bound by a new set of social constraints. The Great Depression now called into question the whole enterprise of modernism and its progressive ethos, ultimately rendering any explicit engagement with form in painting as wantonly self-indulgent, out of sync with an imperiled economy. Thomas Craven, for example, became one of the most assertive champions of a resurgence of narrative painting. His conservative invective spewed from the pages of *Scribner's Magazine* and the *American Mercury*, where the work of Thomas Hart Benton, John Steuart Curry (1897–1946), and Grant Wood (1891–1942) exemplified a "social point of view."[161] Their largely sanitized versions of America, and its bounty, history, and destiny, offset and challenged Stieglitz's use of the landscape as a vehicle for transcendence. There were very few artists within Stieglitz's circle about whom Craven would deign to write. In his estimation, their work succumbed to "the vogue in French fripperies."[162] It did not exhibit enough native character or gumption. Whereas Rosenfeld had employed Freudian theory to explain his exuberance for American modernism, Craven morphed Rosenfeld's masculine/feminine terminology into overt macho verbiage. Craven allied Marin with O'Keeffe in his ongoing appraisals of American art, albeit with increasing reservations as to what they could legitimately add to its extensions. In "American Men of Art," an essay that secured his prominence as a critic, Craven insisted:

> Of the two thoroughbreds from Stieglitz's purified stable, Marin and O'Keeffe, there is little to say as it related to the general unfolding of American art. Neither attempts the representations of American life; both are conventionally reticent, painting still-life and landscape but with esoteric leanings and a delight in cryptic suggestion. O'Keeffe makes large patterns out of small flowers, paints them beautifully, and brings to work a love for the subject which separate her, at once, from the ordinary still-life specialists to whom a bowl of flowers is only a burst of color or a pretext for abstraction.[163]

And while Craven omitted Dove from his narrow purview, in 1931 Dove predicted that Craven's ideology would have a limited life span, contending that "Craven is the Big Bertha and I don't think [his ideas are] going

FIG. 76

Photographer unknown
(possibly Berenice Abbott),
Elizabeth McCausland,
c. 1935. Photograph, 5½ x
4⅜ in. (14 x 11 cm).
Elizabeth McCausland
Papers, 1838–1965,
Archives of American Art,
Smithsonian Institution,
Washington, D.C.

to be used after the war."[164] (By "war," Dove was referring to the aesthetic debates between the polarized factions of writers: those who advocated for modernism and those who sought a revival of figurative art.) Throughout the 1930s Dove continued to rail against Craven in his correspondence with Stieglitz, wondering if Craven had caused "harm" to the prospects for modernist cultures.[165]

Elizabeth McCausland (1899–1965; fig. 76), a journalist who wrote for various publications, including *Parnassus*, *Magazine of Art*, and the *Springfield Union and Republican*, made much more of O'Keeffe's "flower paintings" than Craven, even though she reneged on her modernist preferences with the onset of the Depression, eventually leaning toward documentary photography, especially representations of labor and poverty. Dove and O'Keeffe, though, were exempt from her renewed aesthetic allegiances. She indirectly took on Craven and his depictions of O'Keeffe's increasingly decorative paintings of plant specimens, arguing that "[t]his emphasis on the so called 'preciousness' of her painting . . . does not seem, from a detached critical point of view, to be just."[166] McCausland's own "point of view" was hardly disengaged or neutral, as it was equally grounded in a polemic perpetuating a radical aesthetic now deemed depleted and spent.

As the 1930s wore on and O'Keeffe's work became untethered from Dove's, no longer part of a vital, critical equation, a new generation of modernist critics rose with a vengeance to assail her painting. George L. K. Morris, a founding editor and the first art critic of the newly restructured *Partisan Review* — a publication that would redefine the promise of modernism — evaluated O'Keeffe's entire output by declaring in 1938, "You were

deluded from the beginning, Miss O'Keeffe. . . . The subject-matter in your first pictures — the gigantic flowers — was arresting to begin with; but from the start your limitations were plain. You could ingratiate with an image, but the art of painting itself, the necessary technical equipment, did not come naturally to your fingers. . . . How soon you were to exhaust your repertoire! Your flower-pictures grew tiresome; even the sexual over-meanings became sticky and dull."[167] Morris never unleashed his wrath on Dove, no doubt convinced that his work was more uncompromising in its experimentation. But then Dove's work always existed outside of Morris's loop, never part of the Cubist track that Morris envisaged for the renewal of modernism in the United States.

Morris would delve more deeply than Stieglitz and his circle into the work of Clive Bell, resurrecting his concept of "significant form" in his articles for *Partisan Review* to establish a more reliable conceptual standard for American art. Like Bell, Morris envisaged a linear teleological formation of art knit together through a presumed succession of like stylistic events. Of course, O'Keeffe and her rambling subjects, with their disparate treatments, could never fit this criterion. And Dove would never acquiesce to the supposition that Paris still represented the epicenter of modernism. Fairfield Porter (1907–1975), a figurative artist who later contributed to *Artnews*, subsequently questioned Morris's reasoning and prescriptions for art, wondering especially how he alighted on O'Keeffe. Whereas Morris had written with boundless enthusiasm about Jean Hélion (1904–1987), the French émigré artist, for *Partisan Review*, Porter felt that the screed Morris had unleashed on O'Keeffe was more apt for Hélion: "His criticism of Georgia O'Keeffe, which may be justified, is however perhaps even more applicable, for a person who simply looks at pictures, to his friend Helion. Helion and O'Keeffe have different lines of talk, one is therefore avant-garde and the other commercial."[168] Naturally, Porter knew why O'Keeffe had been left out of Morris's discourse: like his own realistic landscapes, her recognizable imagery could not be accommodated within Morris's critical platform.

Morris's formalist agenda climaxed in the equally acerbic pontifications of his successor at the *Partisan Review*, Clement Greenberg, who in 1942 would quickly go on to become the art critic for the *Nation* and hence a more prominent writer. As Greenberg waded through and repackaged formalism — he claimed never to have read de Zayas and Haviland or Wright, let alone Morris, since his alleged sources and influences were always external, such as the poetics of T. S. Eliot — he consciously avoided Stieglitz's circle, shunting their achievement with the withering declaration that their "non-naturalist art [was] a vehicle for an esoteric message."[169] Both Craven and Greenberg drew upon the word "esoteric" to describe this art, providing

FIG. 77

Arthur Dove, *Fields of Grain as Seen from Train*, 1931. Oil on canvas, 24 x 34⅛ in. (61 x 86.7 cm). Albright-Knox Art Gallery, Buffalo, New York. Gift of Seymour H. Knox, Jr., 1958

ALM 31.9; DBB PL. 57

FIG. 78

Arthur Dove, *Nature Symbolized No. 2*, c. 1911. Pastel on paper, 18 x 21¾ in. (45.8 x 55 cm). The Art Institute of Chicago. Alfred Stieglitz Collection

ALM 11/12.5; DBB FIG. 5

FIG. 79

Georgia O'Keeffe, *Evening Star No. III*, 1917. Watercolor on paper, 8⅞ x 11⅞ in. (22.5 x 30.2 cm). The Museum of Modern Art, New York. Mr. and Mrs. Donald B. Straus Fund

BBL 201

an incredulous yet revealing pairing, as their differing aesthetic positions were equally hardheaded, intolerant, and unmalleable. Other figures, however, continued to ensure the prominence of Dove and O'Keeffe. When early American modernism made a comeback in the 1970s, Harold Rosenberg (1906–1978), Greenberg's chief rival, saw their work as "closer to the animation . . . of Futurism and Expressionism," contending that "the riptides of black diagonals in Dove's 'Field of Grain Seen from Train' [fig. 77] . . . and 'Nature Symbolized' [fig. 78] anticipate [Franz] Kline, while . . . O'Keefe's [*sic*] 'Evening Star' [fig. 79] resemble[s] Helen Frankenthaler's, though O'Keefe is somewhat closer to nature."[170] These ascriptions were abundantly relevant given that Rosenberg had little truck for formal continuity and was drawn more to the correspondences in each artist's subjectivity. He had unwittingly invoked the comparisons that Rosenfeld and others had brought to the work of Dove and O'Keeffe in the 1920s, bringing the interpretations full circle.

Notes

The first epigraph is taken from Herman Melville, *Pierre, or, the Ambiguities* (New York: Harper and Brothers, 1852), 466. The second epigraph is from Irving Berlin, "I've Got the Sun in the Morning," from the musical *Annie Get Your Gun*, 1946.

1. Georgia O'Keeffe, quoted in Katharine Kuh, "Georgia O'Keeffe," *The Artist's Voice: Talks with Seventeen Artists* (New York: Harper & Row, 1962), 189.

2. For a chronology of O'Keeffe's life, see Barbara Buhler Lynes, *Georgia O'Keeffe: Catalogue Raisonné*, 2 vols. (New Haven, Conn.: Yale University Press, 1999), 2:1142–47.

3. Though this work was titled *Dead Rabbit with Copper Pot* in the exhibition at the Art Students League, it is listed as *Untitled* in Lynes, *Georgia O'Keeffe*, no. 39, since there is no documentation of how O'Keeffe herself titled the work.

4. Georgia O'Keeffe, quoted in Kuh, "Georgia O'Keeffe," 189.

5. Georgia O'Keeffe, quoted in Ralph Looney, "Georgia O'Keeffe," *Atlantic Monthly*, Apr. 1965, 107.

6. Georgia O'Keeffe, *Georgia O'Keeffe* (New York: Viking Press, 1976), n.p.

7. O'Keeffe had also studied with Frank Vincent DuMond (1865–1951) and F. Luis Mora (1874–1940) at the Art Students League. DuMond was an Impressionist painter who focused primarily on landscapes and figure drawings. Mora was an artist of Uruguayan descent who worked as a portrait painter, a muralist, and an illustrator for *Century*, *Harper's Monthly Magazine*, and *Ladies' Home Journal*.

8. Georgia O'Keeffe, quoted in William Innes Homer, "Abiquiu is a long way for you to come," *American Art* 20, no. 3 (Fall 2006): 11.

9. For a recent discussion of Alfred Stieglitz's exhibitions of Cézanne's work at 291, see Jill Kyle, "Paul Cézanne, 1911: Nature Reconstructed," in *Modern Art and America: Alfred Stieglitz and His New York Galleries*, exh. cat., ed. Sarah Greenough (Washington, D.C.: National Gallery of Art, 2001), 101–15.

10. Georgia O'Keeffe to Alfred Stieglitz, 27 Jul. 1916, in Jack Cowart and Juan Hamilton, *Georgia O'Keeffe, Art and Letters* (Washington, D.C.: National Gallery of Art; Boston: New York Graphic Society Books, 1987), 153–54.

11. Anita Pollitzer to Georgia O'Keeffe, 1 Jan. 1916, in *Lovingly, Georgia: The Complete Correspondence of Georgia O'Keeffe and Anita Pollitzer*, ed. Clive Giboire, introduction by Benita Eisler (New York: Simon & Schuster, 1990), 115.

12. "Georgia O'Keeffe — C. Duncan — René Lafferty," *Camera Work* 48 (Oct. 1916): 12.

13. See, for example, Eisler, introduction to *Lovingly, Georgia*, xxv.

14. Georgia O'Keeffe to Anita Pollitzer, 4 Jan. 1916, in *Lovingly, Georgia*, 117–19.

15. Anita Pollitzer to Georgia O'Keeffe, October 1915, in ibid., 61.

16. On the rift between Marius de Zayas and Stieglitz, see Debra Bricker Balken, *Debating American Modernism: Stieglitz, Duchamp and the New York Avant-Garde*, exh. cat. (New York: American Federation of Arts and D.A.P., 2003), 41–44.

17. Marius de Zayas to Alfred Stieglitz, 22 Dec. 1910, in Marius de Zayas, *How, When, and Why Modern Art Came to New York*, ed. Francis M. Naumann (Cambridge, Mass.: MIT Press, 1996), 159.

18. Marius de Zayas, "The Modern Gallery," in ibid., 94.

19. Marius de Zayas, "Stieglitz," in ibid., 82.

20. De Zayas's numerous put-downs of Stieglitz are recounted in Balken, *Debating American Modernism*, 41–44.

21. Marius de Zayas, untitled statement, *291* 5–6 (Jul.–Aug. 1915): n.p.

22. Marcel Duchamp, "The Iconoclastic Opinions of M. Marcel Duchamps [*sic*] Concerning Art and America," *Current Opinion* 59 (Nov. 1915): 346.

23. Marius de Zayas, "From *291* — July — August Number, 1915," in *Camera Work: A Critical Anthology*, ed. Jonathan Green (New York: Aperture, 1973), 323.

24. Marius de Zayas and Paul B. Haviland, *A Study of the Modern Evolution of Plastic Expression* (New York: 291, 1913), 20.

25. Clive Bell, *Art* (New York: Frederick A. Stokes Company, 1913). There is no evidence that Bell knew of de Zayas and Haviland's work or vice versa. However, it is likely that the three men subsequently discussed Bell's ideas. De Zayas met a close friend of Bell's, Roger Fry, in London in 1914.

See Marius de Zayas to Alfred Stieglitz, 11 Jun. 1914, in de Zayas, *How, When, and Why Modern Art Came to New York*, 176, where de Zayas refers to Fry as the "head of the modern movement of art in London."

26. De Zayas and Haviland, *A Study of the Modern Evolution of Plastic Expression*, 16.

27. Marius de Zayas, "The Evolution of Form, Introduction," *Camera Work* 41 (Jan. 1913): 45.

28. Marius de Zayas, "The Sun Has Set," *Camera Work* 39 (Jul. 1912): 21.

29. De Zayas, "The Evolution of Form," 48.

30. See note 20.

31. Marius de Zayas, "Clouds: Photographs by Stieglitz," in de Zayas, *How, When, and Why Modern Art Came to New York*, 211.

32. Stieglitz obtained a copy of *A Study of the Modern Evolution of Plastic Expression* shortly after it was printed; O'Keeffe eventually acquired this copy for her library. Many of the books in her library were either gifts from Stieglitz or came into her possession after his death. See Ruth E. Fine, "Books as Bones," in *The Book Room: Georgia O'Keeffe's Library in Abiquiu*, exh. cat. (New York: The Georgia O'Keeffe Foundation and the Grolier Club, 1997), 11–16. Moreover, we know from O'Keeffe's correspondence with Pollitzer that as of 1915 she had a subscription to *Camera Work*. I am surmising that she eventually read de Zayas's two essays in the journal, given her reference to de Zayas in a subsequent letter. For further information on O'Keeffe's reading and critical attempts to verify her sources, see note 46 below.

33. For writing concerning the unconscious in the pages of *Camera Work*, see, for example, Nancy E. Green, *Arthur Wesley Dow and American Arts & Crafts*, exh. cat. (New York: The American Federation of Arts in association with Harry N. Abrams, 1999), 214.

34. O'Keeffe's life from 1909 to 1918 was peripatetic, characterized by numerous teaching positions in various locales. Her education was interrupted frequently by family obligations. For a list of these wanderings and appointments, see Lynes, *Georgia O'Keeffe*, 2:1142–43.

35. Georgia O'Keeffe, quoted in O'Keeffe, *Georgia O'Keeffe*, pl. 12 verso.

36. Georgia O'Keeffe to Anita Pollitzer, Oct. 1915, in *Lovingly, Georgia*, 66.

37. Georgia O'Keeffe, quoted in O'Keeffe, *Georgia O'Keeffe*, pl. 12 verso.

38. Noted by Sarah L. Burt, "Georgia O'Keeffe's Library," in *The Book Room*, 41–42. The 1914 American edition of Kandinsky's tract that O'Keeffe eventually acquired was titled *The Art of Spiritual Harmony*; it would remain in her library at Abiquiu until her death.

39. Georgia O'Keeffe to Anita Pollitzer, 25 Aug. 1915, in *Georgia O'Keeffe, Art and Letters*, 143.

40. Ibid., 146.

41. Wassily Kandinsky, "Extracts from 'The Spiritual in Art,'" *Camera Work* 39 (Jul. 1912): 34.

42. Of the many studies on O'Keeffe and Dow, see, for example, Charles C. Eldredge, "Georgia O'Keeffe: American and Modern," in *Georgia O'Keeffe: American and Modern*, exh. cat. (New Haven, Conn.: Yale University Press, 1993), 160–61. Nancy E. Green, "Arthur Wesley Dow, Artist and Educator," in *Arthur Wesley Dow and American Arts & Crafts*, notes that "in his lectures on modernism, Dow only taught up to the work of Manet and Monet. Though he did not understand modernism in all its complications and rhetoric, he appreciated its rejection of academic teaching and its connections with music" (82). Green also notes that in 1915 Dow "added a course in modernist painting to the curriculum at Teachers College" (ibid.). Gail Levin has observed, in "Kandinsky and the First American Avant-Garde," in *Theme and Improvisation: Kandinsky and the American Avant-Garde, 1912–1950*, exh. cat. (Boston: Little, Brown, 1992), 22–48, that Dow was aware of Kandinsky as of 1917, that is, after O'Keeffe studied with Dow. But Levin shows that Dow's interest in Kandinsky was limited, that he deemed Japanese artists such as Keisai Yeisen far more important.

43. Wassily Kandinsky, *Concerning the Spiritual in Art and Painting in Particular, 1912*, Documents of Modern Art, vol. 5 (New York: Wittenborn Art Books, 1947), 45.

44. Ibid., 45, 51.

45. Ibid., 54.

46. Georgia O'Keeffe to Anita Pollitzer, Jan. 1917, in *Lovingly, Georgia*, 238. Sarah Greenough, in "Notes to the Letters," in *O'Keeffe, Art and Letters*, 276, attempts to identify the sources that O'Keeffe mentions in her letters to Pollitzer, Stieglitz, Strand, and others, based (I assume) on the contents of her libraries at Abiquiu and Ghost Ranch. Greenough states that O'Keeffe was referring to Marius de Zayas's volume *African Negro Art: Its Influences on Modern Art* (New York: The Modern Gallery, 1916). Burt, "Georgia O'Keeffe's

Library," 26, has noted that Stieglitz sent O'Keeffe a copy of this volume for her birthday in the fall of 1916. The library at Abiquiu also contains a copy of de Zayas and Haviland, *A Study of the Modern Evolution of Plastic Expression* (inscribed by Stieglitz). Greenough also lists Willard Huntington Wright, *The Creative Will: Studies in the Philosophy of Aesthetics* (New York: John Lane, 1916) as one of the books that O'Keeffe read when preparing for her talk at West Texas State Normal College. The volume does not appear in either of her libraries, whereas the copy of the *Forum Exhibition* catalogue does, along with Wright's *What Nietzsche Taught* (New York: B. W. Huebsch, 1915). The latter volume has been inscribed "January 1917" by O'Keeffe, which post-dates her talk. Moreover, the volume does not address her topic of "aesthetics." In my view, Greenough's citation remains conjectural; I believe the attribution of such sources such should remain fluid, such as those Burt has made in her entries for "Georgia O'Keeffe's Library."

47. Clive Bell, "The Debt to Cézanne," in *Art* (London: Chatto and Windus, 1928), 206.

48. Willard Huntington Wright, *Modern Painting: Its Tendency and Meanings* (New York: John Lane, 1915), 22.

49. Ibid., 308.

50. Marius de Zayas, "The Modern Quest After Abstract Beauty," in *How, When, and Why Modern Art Came to New York*, 39. In a letter that de Zayas wrote to Stieglitz from London on 11 July 1914, he recounts that he saw work by Kandinsky in a show that Roger Fry had mounted at Holland Hall: "[T]his exhibition is the Independents of England. I saw all the paintings. Not a single thing worth while and lots of very, very, very bad stuff. Kandinsky has three pictures there. One is good the other two pretty poor" (ibid., 176). Kandinsky was not discussed in de Zayas's collaboration with Paul Haviland, *A Study of the Modern Evolution of Plastic Expression*.

51. Kandinsky, "Extracts from 'The Spiritual in Art,'" 34.

52. See Burt, "Georgia O'Keeffe's Library," 30.

53. Balken, *Debating American Modernism*, 37.

54. There have been various speculations as to why Dove did not participate in the Armory Show, ranging from loyalty to Stieglitz, who was a sponsor but not an organizer of the event, to not having the time to produce a new body of work to exhibit. For a synopsis of these possibilities, see Ann Lee Morgan, *Arthur Dove, Life and Work, with a Catalogue Raisonné* (Newark: University of Delaware Press, 1984), 18.

55. Arthur Jerome Eddy, *Cubists and Post-Impressionism* (1914; repr., Chicago: A. C. McClurg, 1919), 48. In the 1919 edition of the book, Eddy removed his qualification that Dove did not completely measure up to his European peers, and I have chosen to cite that edition here, as this quotation is more relevant to my essay.

56. Georgia O'Keeffe, quoted in Suzanne Mullett, "Arthur G. Dove (1880–), A Study in Contemporary Art" (M.A. thesis, American University, Washington, D.C., 1944), 27. O'Keeffe reiterated part of this quote many years later in an interview with William Innes Homer, which he incorporated into *Alfred Stieglitz and the American Avant-Garde* (Boston: New York Graphic Society, 1977), 236.

57. Curatorial records for *Movement No. 1* (plate 5) indicate that the image was reproduced with incorrect orientation in both Morgan, *Arthur Dove, Life and Work* and Debra Bricker Balken, *Arthur Dove: A Retrospective*, exh. cat. (Andover, Mass.: Addison Gallery of American Art; Cambridge, Mass.: MIT Press, in association with the Phillips Collection, Washington, D.C., 1997). Some of Dove's pastels from 1911–12 have been referred to as the "Ten Commandments." They are discussed by William Innes Homer in "Identifying Arthur Dove's 'The Ten Commandments,'" *American Art Journal* 12, no. 3 (Summer 1980): 21–32. The origins of this designation remain speculative, as do the works that comprise the so-called group. Did Dove or Stieglitz project this biblical reference onto a body of work exhibited at 291 and later at the Thurber Galleries? Morgan, 43–44, has also attempted to sort through the conjectures to identify the contents of the exhibition. In the absence of an exhibition list, I'll stay out of the fray.

58. Georgia O'Keeffe, quoted in Mullett, "Arthur G. Dove," 27.

59. There is little documentation pertaining to Dove's trip to France except for titles of paintings that place him in the Île-de-France and the southeastern section of the country, near the Italian border. See Balken, "Continuities and Digressions in the Work of Arthur Dove from 1907 to 1933," in *Arthur Dove: A Retrospective*, 17–93.

60. Georgia O'Keeffe, quoted in Calvin Tomkins, "The Rose in the Eye Looked Pretty Fine," *New Yorker*, 30 Mar. 1974, 62.

61. On Eddy and his collection, see Paul Kruty, "Arthur Jerome Eddy and His Collection: Prelude and

Postscript to the Armory Show," *Arts Magazine* 61, no. 6 (Feb. 1987): 40–47.

62. Eddy, "Exhibitions at 291 Fifth Avenue," in *Cubists and Post-Impressionism*, 211–13. Stieglitz wrote the entry for the volume. On the many accolades that would be devoted to Stieglitz in print, see Balken, *Debating American Modernism*, 56–58, and Debra Bricker Balken, *After Many Springs: Regionalism, Modernism, and the Midwest*, exh. cat. (Des Moines, Iowa: Des Moines Art Center; New Haven, Conn.: Yale University Press, 2009). De Zayas and Haviland set the tone for this commemorative pattern in *A Study of the Modern Evolution of Plastic Expression* by devoting an entire section to Stieglitz. But Stieglitz had underwritten the volume to ensure his presence during the run of the Armory Show.

63. On the early-twentieth-century collectors associated with modernist developments in the United States, see Debra Bricker Balken, "On the American Collectors Who Emerged in the Wake of the Armory Show," in *Ferdinand Howald*, exh. cat. (Columbus, Ohio: Columbus Museum of Art, forthcoming 2010).

64. Eddy, *Cubists and Post-Impressionism*, 200.

65. Ibid., 196.

66. Arthur Dove, quoted ibid., 48.

67. Arthur Dove, quoted in Helen Torr Dove, "Notes," Arthur and Helen Torr Dove Papers, 1905–1974, reel 4682, frame 63, Archives of American Art, Smithsonian Institution, Washington, D.C.

68. Helen Torr Dove, "Notes."

69. Arthur Dove, quoted in Samuel M. Kootz, *Modern American Painters* (New York: Brewer & Warren, 1930), 37.

70. I have been unable to pinpoint the precise date of Dove and Stieglitz's first meeting, as there is no archival evidence to situate their encounter.

71. Max Weber, quoted in Homer, *Alfred Stieglitz and the American Avant-Garde*, 114.

72. On Dove and the community of expatriate American artists in Paris, see Balken, "Continuities and Digressions," 19.

73. Dove's illustrations have been studied by Barbara D. Gallati, "Arthur G. Dove as Illustrator," *Archives of American Art Journal* 21, no. 2 (1981): 13–22.

74. Arthur Dove, quoted in H. Effa Webster, "Artist Dove Paints Rhythms of Color," *Chicago Examiner*, 15 Mar. 1912, 12.

75. Alfred Stieglitz, quoted in Samuel Swift, review of Francis Picabia's *Studies of New York*, at 291, *New York Sun*, Mar. 1913, reprinted as "Samuel Swift

in the 'N.Y. Sun,'" *Camera Work* 42–43 (Apr.–Jul. 1913): 48.

76. Alfred Stieglitz to Wassily Kandinsky, 26 May 1913, Stieglitz/O'Keeffe Archive, Yale Collection of American Art and Literature (hereafter YCAL), Beinecke Rare Book and Manuscript Library, New Haven, Conn.

77. Levin, in "Kandinsky and the First American Avant-Garde," 22, categorically states that Dove saw Kandinsky's *Improvisation No. 27* both at the Armory Show and "later at 291," but she provides no citation or evidence. Dove's exhibition at 291 took place in February 1912, while Kandinsky's extract appeared in *Camera Work* in July of that year, a chronology that would seem to counter Levin's connection.

78. See Balken, "Continuities and Digressions," 22.

79. Arthur G. Dove, *An Idea*, exh. brochure (New York: The Intimate Gallery, 1927), n.p.; Arthur and Helen Torr Dove Papers, 1905–1974, box 3, folders 21–25, Archives of American Art, Smithsonian Institution, Washington, D.C.

80. Eddy, *Cubists and Post-Impressionism*, 191.

81. Ibid., 192.

82. Paul Rosenfeld, "American Painting," *Dial* 71 (Dec. 1921): 665.

83. I have discussed these connections in *Debating American Modernism*, 33–36, 54–58.

84. Waldo Frank, *Our America* (New York: Boni & Liveright, 1919), 183–84.

85. Willard Huntington Wright, "The Truth About Painting," *Forum* 54 (Jul.–Dec. 1915): 445.

86. Arthur Dove to Alfred Stieglitz, probably 22 May 1917, in *Dear Stieglitz, Dear Dove*, ed. Ann Lee Morgan (Newark: University of Delaware Press, 1988), 53.

87. See Morgan, *Arthur Dove, Life and Work*, 19 n. 24.

88. Arthur G. Dove, "Statement," in *The Forum Exhibition of Modern American Painters: March 13th to March 25th, 1916*, exh. cat. (New York: Anderson Galleries, 1916), n.p.

89. Arthur Dove to Alfred Stieglitz, 19 Oct. 1914, in *Dear Stieglitz, Dear Dove*, 41. This letter is the first to survive from their correspondence.

90. Alfred Stieglitz to Arthur Dove, 5 Nov. 1914, in ibid., 42

91. Ibid. On the women artists whom Stieglitz had exhibited at 291, see Kathleen Pyne, *Modernism and the Feminine Voice: O'Keeffe and the Women of the Stieglitz Circle* (Berkeley: University of California Press, 2007).

92. Sherwood Anderson to Arthur Dove, late 1921,

Sherwood Anderson Papers, Newberry Library, Chicago.

93. For examples of O'Keeffe's lingering debt to Art Nouveau themes and forms in her work, see Lynes, *Georgia O'Keeffe: Catalogue Raisonné*, 1:103.

94. I offer Dove's *Abstraction No. 3* as a point of comparison with O'Keeffe's *No. 24 — Special/No. 24*. Unlike his *Plant Forms*, which appeared at the *Forum Exhibition*, I cannot substantiate that she saw this painting. But the overall similarities are striking and suggest some contact with the work.

95. For a discussion of the date of Dove's *Abstraction, Number 2*, see Balken, "Continuities and Digressions," nn. 31, 35.

96. Georgia O'Keeffe to Anita Pollitzer, Feb. 1916, in *Lovingly, Georgia*, 131.

97. Henry Tyrrell, "New York Art Exhibition and Gallery Notes: Esoteric Art at '291,'" *Christian Science Monitor*, 4 May 1917, 10, reprinted in Barbara Buhler Lynes, *O'Keeffe, Stieglitz and the Critics, 1916–1929* (Ann Arbor, Mich.: UMI Research Press, 1989), 168. Research indicates that *Blue I* is a vertical work, though it was hung horizontally in the 1917 installation at 291. See Lynes, *Georgia O'Keeffe*, no. 119.

98. Tyrrell, "New York Art Exhibition and Gallery Notes."

99. Ibid. Tyrrell's idea of a duality is taken from the diary of Maria Bashkirtseff (1858–1884), a Russian artist and feminist who studied in Paris in the 1880s.

100. Ibid.

101. Georgia O'Keeffe to Anita Pollitzer, 4 Jan. 1916, in *Lovingly Georgia*, 117.

102. Georgia O'Keeffe, quoted in Gladys Oaks, "Radical Writer and Woman Artist Clash on Propaganda and Its Uses," *New York World*, 16 Mar. 1930, woman's section, 1, 3. Sarah Whitaker Peters, in *Becoming O'Keeffe: The Early Years*, 2nd ed. (New York: Abbeville Press, 2001), 16, has also cited this quote, but our positions differ greatly in that I am more interested in the progressive traits of O'Keeffe's work, its position within the context of American modernism. I do not seek, as Peters does, to "de-idealize what she did . . . to open my mind" (17).

103. Alfred Stieglitz to Arthur Jerome Eddy, 28 Mar. 1916, Stieglitz/O'Keeffe Archives, YCAL.

104. Alfred Stieglitz to Arthur Dove, late Jul. 1918, in *Dear Stieglitz, Dear Dove*, 61.

105. Alfred Stieglitz to Arthur Dove, 15 Aug. 1918, in ibid., 62.

106. Paul Rosenfeld to Alfred Stieglitz, 12 Aug. 1918, Stieglitz/O'Keeffe Archive, YCAL.

107. Henry McBride, "O'Keeffe at the Museum," *New York Sun*, 18 May 1946, quoted in Richard Whelan, *Alfred Stieglitz: A Biography* (Boston: Little, Brown, 1995), 418.

108. Henry McBride, "Steiglitz's [sic] Life Work in Photography," *New York Herald*, 13 Feb. 1921, reprinted as "Photographs by Stieglitz," in *The Flow of Art: Essays and Criticism of Henry McBride*, ed. Daniel Catton Rich (New Haven, Conn.: Yale University Press, 1997), 161.

109. Georgia O'Keeffe, "To MSS, and Its 33 Subscribers and Others Who Read and Don't Subscribe!" *MSS* 4 (Dec. 1922): 17.

110. Thomas Craven, "Art and the Camera," *Nation*, 16 Apr. 1924, 457.

111. Alfred Stieglitz, quoted in Dorothy Norman, *Alfred Stieglitz: An American Seer* (New York: Aperture Books, 1990), 136.

112. Thomas Craven, "American Men of Art," *Scribner's Magazine*, Nov. 1932, 262.

113. On the critical interchange among Craven, Stieglitz, and Benton, see Balken, *After Many Springs*.

114. Belinda Rathbone, Roger Shattuck, and Elizabeth Hutton Turner, *Two Lives, Georgia O'Keeffe and Alfred Stieglitz: A Conversation in Paintings and Photographs*, exh. cat. (New York: HarperCollins, 1992), have paired the work of these figures but never fully excavated the critical context in which such a pairing emerged. They largely ignore the body of discourse discussed in this essay.

115. Rosenfeld, "American Painting," 666.

116. Marin frequently inserted images of figures in his paintings as well as produced portraits of his family and friends. However, these images are never mined for their erotic potential, even in the case of the sea nymph, which appears in his work after 1933; instead, they are referenced as modernist tropes, specifically evoking Cézanne's *Bathers*.

117. Marsden Hartley, "Some Women Artists in Modern Painting," in *Adventures in the Arts: Informal Chapters on Painters, Vaudeville and Poets* (New York: Boni & Liveright, 1921), 116–17, 119.

118. Ibid., 119.

119. Paul Rosenfeld to Alfred Stieglitz, 18 Jun. 1921, Stieglitz/O'Keeffe Archive, YCAL.

120. Ibid.; Paul Rosenfeld to Alfred Stieglitz, 10 Sept. 1921, Stieglitz/O'Keeffe Archive, YCAL.

121. *Sherwood Anderson's Memoirs: A Critical Edition*,

ed. Ray Lewis White (Chapel Hill: University of North Carolina Press, 1942), 343.

122. Georgia O'Keeffe to Mitchell Kennerley, Fall 1922, in *Georgia O'Keeffe, Art and Letters*, 170–71.

123. Georgia O'Keeffe, statement in *Alfred Stieglitz Presents One Hundred Pictures: Oils, Watercolors, Pastels, Drawings, by Georgia O'Keeffe, American*, exh. brochure (New York: Anderson Galleries, 1923), n.p., reprinted in Lynes, *O'Keeffe, Stieglitz and the Critics, 1916–1929*, 185.

124. Thomas Hart Benton to Alfred Stieglitz, 9 Dec. 1921, Stieglitz/O'Keeffe Archive, YCAL.

125. Paul Rosenfeld to Alfred Stieglitz, 30 Aug. 1920, Stieglitz/O'Keeffe Archive, YCAL.

126. Paul Rosenfeld to Alfred Stieglitz, 10 Sept. 1921, Stieglitz/O'Keeffe Archive, YCAL.

127. Alfred Stieglitz to Arthur Dove, 7 Aug. 1922, in *Dear Stieglitz, Dear Dove*, 82.

128. Arthur Dove to Alfred Stieglitz, probably 25 Jul. 1922, in ibid., 80.

129. Guillaume Apollinaire, quoted in Ann Lee Morgan, "An Encounter and Its Consequences: Arthur Dove and Alfred Stieglitz, 1910–25," *Biography* 2, no. 1 (Winter 1979): 48.

130. Alfred Stieglitz to Paul Rosenfeld, 5 Sept. 1923, Stieglitz/O'Keeffe Archive, YCAL. Marcia Brennan, in *Painting Gender, Constructing Theory: The Alfred Stieglitz Circle and American Formalist Aesthetics* (Cambridge, Mass.: MIT Press, 2001), 100, maintains that Stieglitz "collaborated" with Rosenfeld on his essay on Dove for *Port of New York*. She notes that Rosenfeld requested permission from Stieglitz "to lift a few phrases" from a letter that referenced Dove. I see this not as collaboration but as part of an ongoing dialogue. Moreover, for a book with a subtitle devoted to "American Formalist Aesthetics," there is no mention of Bell or Apollinaire, let alone of de Zayas and Haviland and their protoformalist sensibility, omissions that I am working to counter.

131. Arthur G. Dove, "An Idea," in *Arthur G. Dove Paintings, 1927* (New York: The Intimate Gallery, 1927), n.p. Recent research indicates that *#4 Creek* was a study for *Penetration* (1924).

132. Samuel M. Kootz, *Modern American Painters* (New York: Brewer & Warren, 1930), 48.

133. Arthur Dove to Alfred Stieglitz, 4 Dec. 1930, in *Dear Stieglitz, Dear Dove*, 202.

134. Ibid., 201.

135. Ibid.

136. Paul Rosenfeld to Alfred Stieglitz, 1 Sept. 1923, Stieglitz/O'Keeffe Archive, YCAL.

137. Rosenfeld, "American Painting," 666. I am consciously leaving John Marin out of this paraphrased quotation, knowing that he would be removed from any such comparison with O'Keeffe as of 1924.

138. Paul Rosenfeld, "Arthur G. Dove," in *Port of New York: Essays on Fourteen American Moderns* (New York: Harcourt, Brace, 1924), 170.

139. Waldo Frank, "White Paint and Good Order," in *Time Exposures* (New York: Boni & Liveright, 1926), 32; Oscar Bluemner, "A Painter's Comment," in *Georgia O'Keeffe: Paintings, 1926*, exh. cat. (New York: The Intimate Gallery, 1927), n.p.

140. Figure 52 is titled *Red Hills with Sun* in Lynes, *Georgia O'Keeffe*, no. 608, though the work is published and exhibited frequently as *Red Hills, Lake George*.

141. Sherwood Anderson, "Alfred Stieglitz," *New Republic*, 25 Oct. 1922, 215.

142. Herbert Seligmann, *Alfred Stieglitz Talking: Notes on Some of His Conversations, 1925–1931* (New Haven, Conn.: Yale University Library, 1966), 24. Anderson is quoted in Sheldon Cheney, *A Primer of Modern Art* (New York: Boni & Liveright, 1924), 239.

143. In part to deflect the sexualized take on her landscapes, in 1925 O'Keeffe embarked on a series of cityscapes — what she thought was a more masculine subject. On this body of work, see Anna C. Chave, "'Who Will Paint New York?': 'The World's New Art Center' and the Skyscraper Paintings of Georgia O'Keeffe," *American Art* 5, no. 1/2, (Winter/Spring 1991): 87–107. Note that *New York with Moon* is titled *New York Street with Moon* in Lynes, *Georgia O'Keeffe*, no. 483.

144. Alfred Stieglitz to Sheldon Cheney, 24 Aug. 1923, Cheney Papers, reel 3947, frames 449–50, Archives of American Art, Smithsonian Institution, Washington, D.C.

145. Arthur Dove to Alfred Stieglitz, 7 Oct. 1923, in *Dear Stieglitz, Dear Dove*, 95.

146. Alfred Stieglitz to Arthur Dove, 15 Aug. 1918, in ibid., 62.

147. Georgia O'Keeffe, quoted in Kuh, "Georgia O'Keefe," 190.

148. Alfred Stieglitz to Arthur Dove, 5 May 1935, in *Dear Stieglitz, Dear Dove*, 337. In this letter Stieglitz told Dove, "She liked your things immensely. — She asked me what I'd let anyone have 6 of your small things for . . ." I have traced one of these watercolors to Juan Hamilton.

149. Arthur Dove to Alfred Stieglitz, 11 Jul. 1930, in *Dear Stieglitz, Dear Dove*, 194. On Dove's use of the watercolor medium, see Debra Bricker Balken, "Arthur Dove's Watercolors," in *Arthur Dove, Watercolors*, exh. cat. (New York: Alexandre Gallery, 2006), 7–11.

150. Arthur Dove, quoted in Kootz, *Modern American Painters*, 38.

151. Arthur Dove to Alfred Stieglitz, 19 Jul. 1930, in *Dear Stieglitz, Dear Dove*, 195.

152. Alfred Stieglitz to Arthur Dove, 5 May 1935, in ibid., 337.

153. Widely known as *The Lawrence Tree*, this work is listed as *D. H. Lawrence Pine Tree* in Lynes, *Georgia O'Keeffe*, no. 687.

154. For more on *Sea Gull Motive*, see Marc Simpson, "Arthur G. Dove's *Sea Gull Motive*," *Triptych* (membership magazine for the M. H. de Young Memorial Museum) 53 (Nov./Dec. 1990): 18–20.

155. Edmund Wilson, "The Stieglitz Exhibition," *New Republic*, 18 Mar. 1925, 97.

156. Henry McBride, "The Stieglitz Group at Anderson's," *New York Sun*, 14 Mar. 1925, reprinted in Lynes, *O'Keeffe, Stieglitz and the Critics*, 226.

157. Blanche C. Matthias, "Georgia O'Keeffe and the Intimate Gallery: Stieglitz Showing Seven Americans," *Chicago Evening Post Magazine of the Art World*, 2 Mar. 1926, 14, reprinted in ibid., 246–47, 249–50.

158. C. J. Bulliet, "The American Scene," in *Apples & Madonnas: Emotional Expression in Modern Art* (Chicago: Pascal Covici, 1927), reprinted in ibid., 272–73.

159. Alfred Stieglitz, quoted in Mullett, "Arthur G. Dove," 26.

160. Arthur Dove, "A Different One," in *American and Alfred Stieglitz: A Collective Portrait*, ed. Waldo Frank (New York: The Literary Guild, 1934), 244.

161. Thomas Craven, *Modern Art: The Men, the Movements, the Meaning* (New York: Simon & Schuster, 1934), 341. On Craven and Stieglitz and their entanglements in the 1930s, see Balken, *After Many Springs*.

162. Thomas Craven, "American Men of Art," *Scribner's Magazine*, Nov. 1932, 267.

163. Ibid., 325.

164. Arthur Dove, "On Reading the Current Papers," in *Dear Stieglitz, Dear Dove*, 218.

165. Arthur Dove to Alfred Stieglitz, 19 Dec. 1934, in ibid., 321. See Balken, *After Many Springs*, 26–31.

166. Elizabeth McCausland, "To Be or Not to Be Precious: Georgia O'Keeffe's Flower Paintings," *Springfield Daily Republican*, 28 Apr. 1935.

167. George L. K. Morris, "Art Chronicle: To Georgia O'Keeffe, An American Place," *Partisan Review*, Mar. 1938, 39.

168. Fairfield Porter, *Material Witness: The Selected Letters of Fairfield Porter*, ed. Ted Leigh (Ann Arbor: University of Michigan Press, 2005), 86. On Morris's promotion of Hélion in *Partisan Review*, see Debra Bricker Balken, "Jean Hélion's New York Connections," in *Jean Hélion*, exh. cat. (Paris: Editions du Centre Pompidou, 2004).

169. Clement Greenberg, "Review of an Exhibition of Georgia O'Keeffe," in *The Collected Essays and Criticism*, vol. 2: *Arrogant Purpose, 1945–1949*, ed. John O'Brian (Chicago: University of Chicago Press, 1986), 86.

170. Harold Rosenberg, "American Drawing and the Academy of the Erased de Kooning," in *Art & Other Serious Matters* (Chicago: University of Chicago Press, 1985), 241.

PLATES

PLATE 1 | **ARTHUR DOVE,** *Abstraction No. 3*, 1910/11. Oil on panel, 9 x 10½ in. (22.9 x 26.7 cm).

Newark Museum. Gift of Henry Ploch, 2000 | ALM 10/11.3; DBB PL. 5

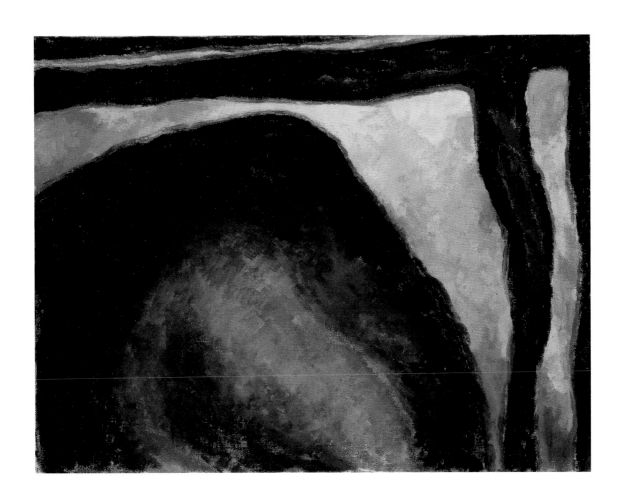

PLATE 2 | **GEORGIA O'KEEFFE,** *No. 24 — Special/No. 24*, 1916/17. Oil on canvas, 18¼ x 24 in. (46.4 x 61 cm).

Georgia O'Keeffe Museum, Santa Fe, New Mexico. Gift of The Georgia O'Keeffe Foundation | BBL 166

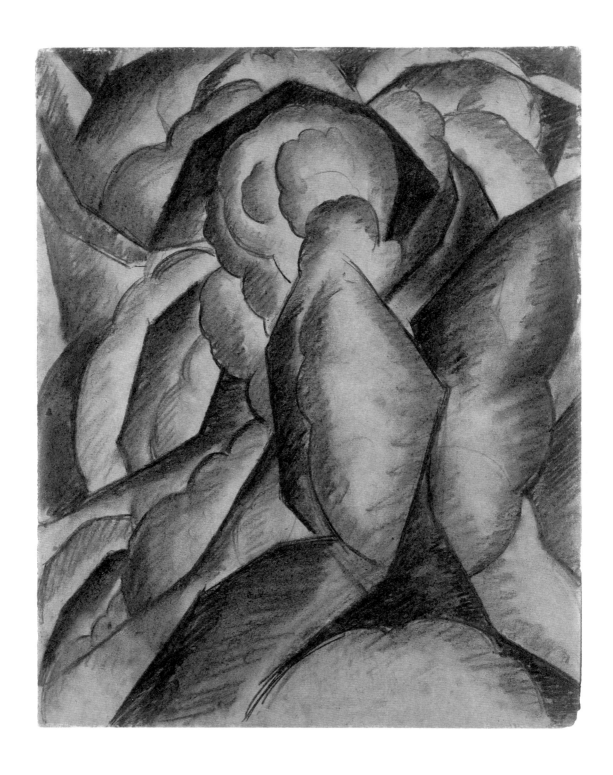

PLATE 3 | **ARTHUR DOVE,** *Drawing [Sunrise II]*, 1913. Charcoal on paper, 21⁷⁄₁₆ x 18 in. (54.5 x 45.7 cm).

Addison Gallery of American Art, Phillips Academy, Andover, Massachusetts. Museum purchase | DBB PL. 13

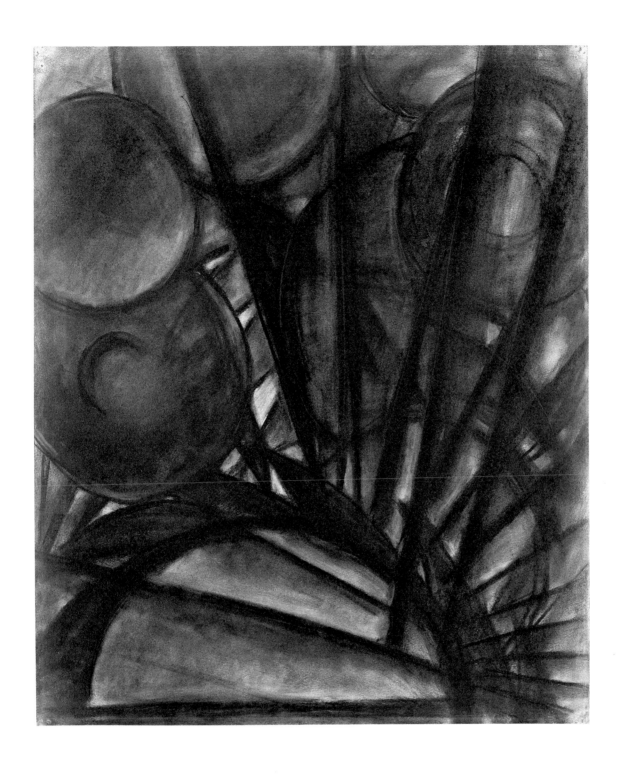

PLATE 4 | **ARTHUR DOVE,** *Abstraction, Number 2,* c. 1911. Chalk and graphite pencil on paper, 21¼ x 17¹³⁄₁₆ in.

(54 x 45.2 cm). Whitney Museum of American Art, New York. Purchase | DBB PL. 16

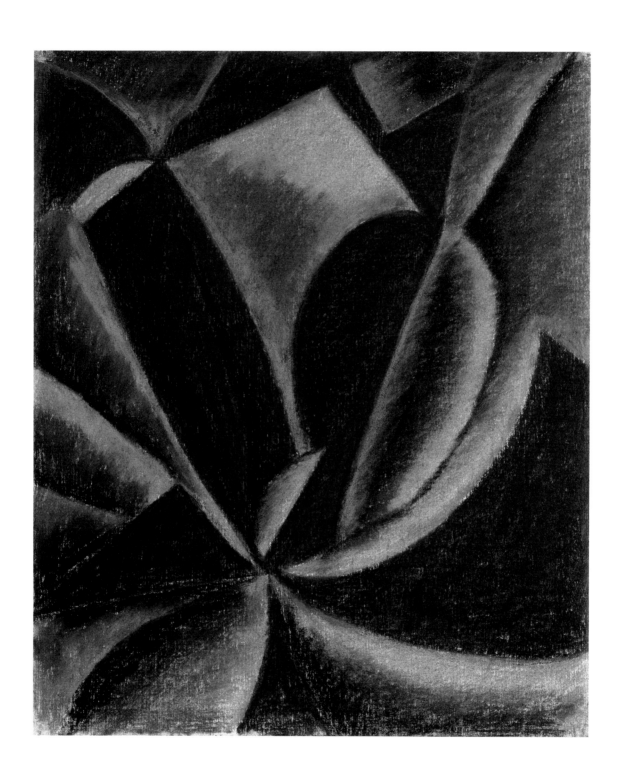

PLATE 5 | **ARTHUR DOVE,** *Movement No. I*, c. 1911. Pastel on canvas, 21³⁄₈ x 18 in. (54.3 x 45.7 cm).
Columbus Museum of Art, Ohio. Gift of Ferdinand Howald | ALM 11/12.3; DBB PL. 7

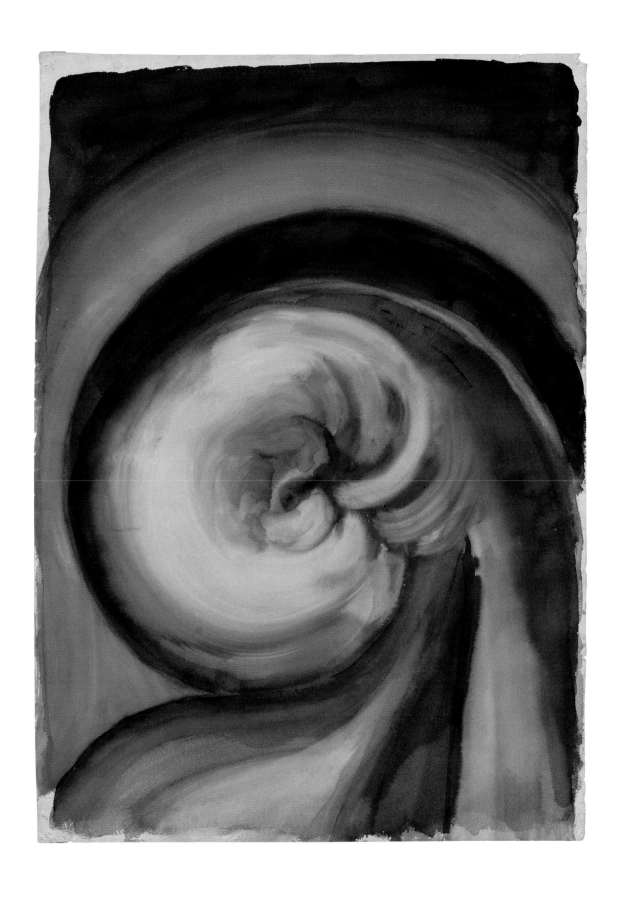

PLATE 6 | **GEORGIA O'KEEFFE,** *Blue I*, 1916. Watercolor on paper, 30⅞ x 22¼ in. (78.4 x 56.5 cm).

Private collection | BBL 119

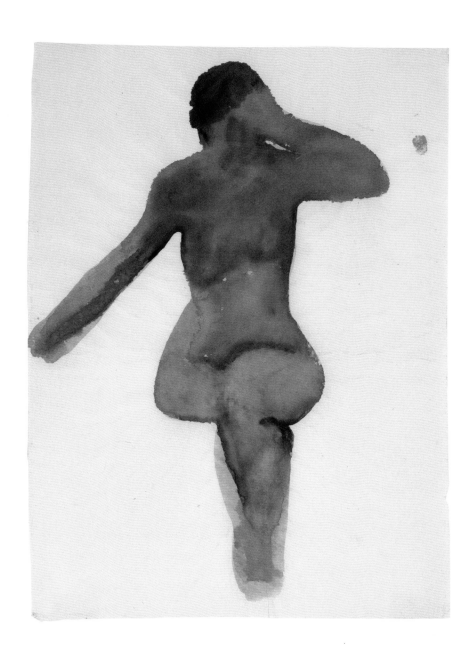

PLATE 7 | **GEORGIA O'KEEFFE,** *Nude Series VIII*, 1917. Watercolor on paper, 18 x 13½ in. (45.7 x 34.3 cm).

Georgia O'Keeffe Museum, Santa Fe, New Mexico.

Gift of The Burnett Foundation and The Georgia O'Keeffe Foundation | BBL 182

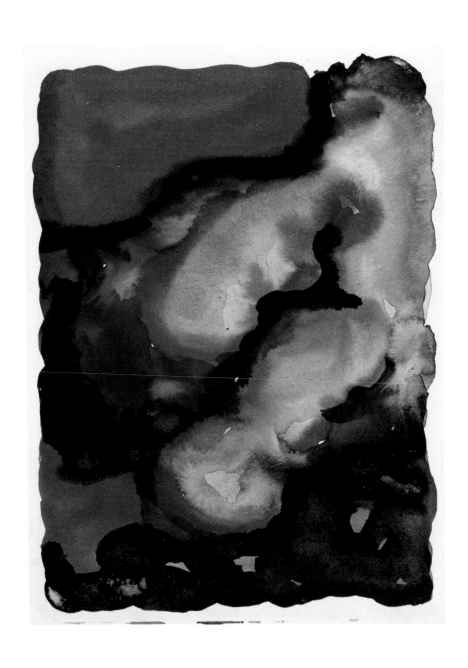

PLATE 8 | **GEORGIA O'KEEFFE,** *Red and Blue No. II*, 1916. Watercolor on paper, 11⅞ x 9 in. (30.2 x 22.9 cm).

Curtis Galleries, Minneapolis | BBL 89

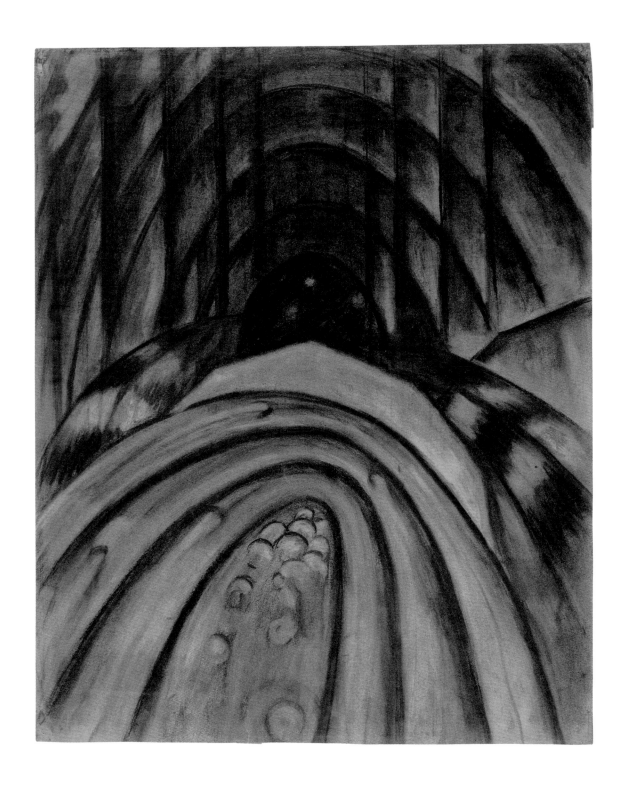

PLATE 9 | **ARTHUR DOVE,** *#4 Creek*, c. 1923. Charcoal and pencil on cream paper, 21³⁄₈ x 17¹³⁄₁₆ in. (54.3 x 45.2 cm).
Corcoran Gallery of Art, Washington, D.C. Museum Purchase | DBB PL. 19

PLATE 10 | **ARTHUR DOVE,** *Penetration*, 1924. Oil on board, 21¼ x 17¾ in. (54 x 45.1 cm).

Collection of Peter and Kirsten Bedford | ALM 24.5; DBB PL. 20

PLATE 11 | **ARTHUR DOVE,** *River Bottom, Silver, Ochre, Carmine, Green,* 1923. Oil on canvas, 24 x 18 in. (61 x 45.7 cm).
Collection of Michael and Fiona Scharf | ALM 23.6; DBB PL. 21

PLATE 12 | **GEORGIA O'KEEFFE,** *Series I — No. 10 A,* 1919. Oil on board, 20¹⁄₈ x 15⁷⁄₈ in. (51.1 x 40.3 cm).

Georgia O'Keeffe Museum, Santa Fe, New Mexico. Gift of The Georgia O'Keeffe Foundation | BBL 290

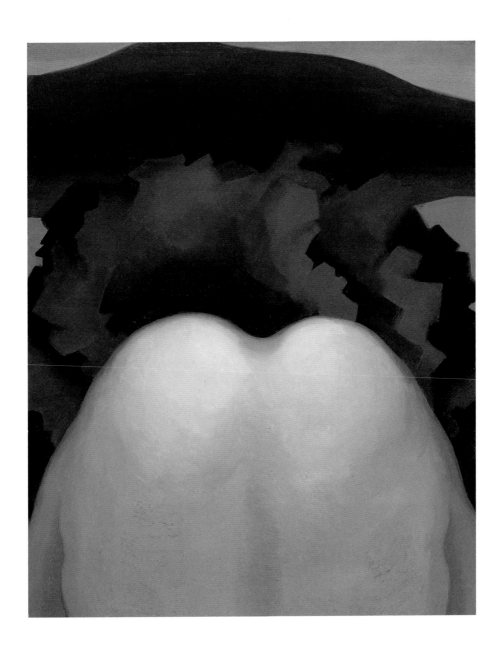

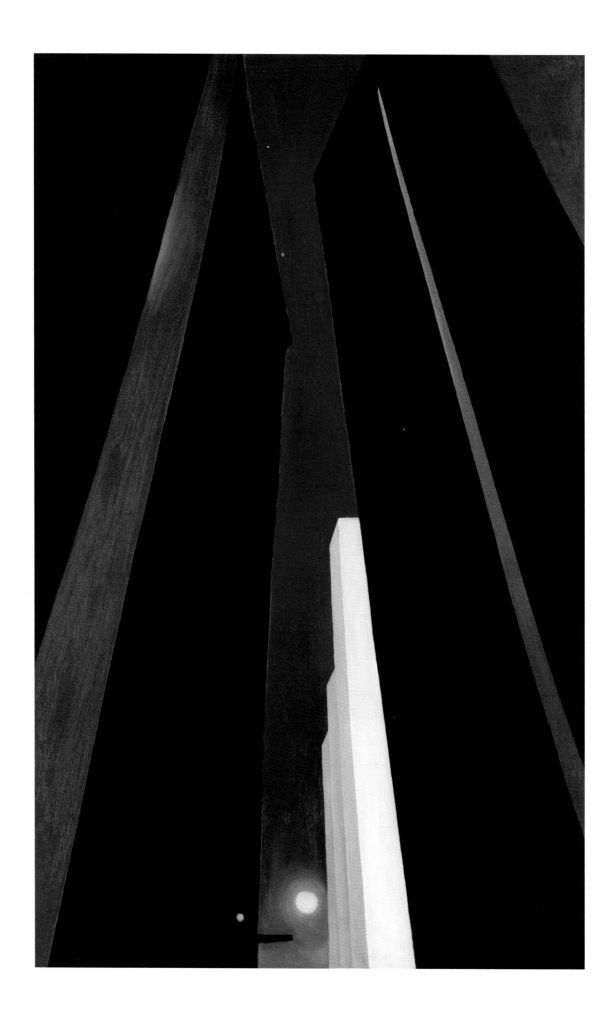

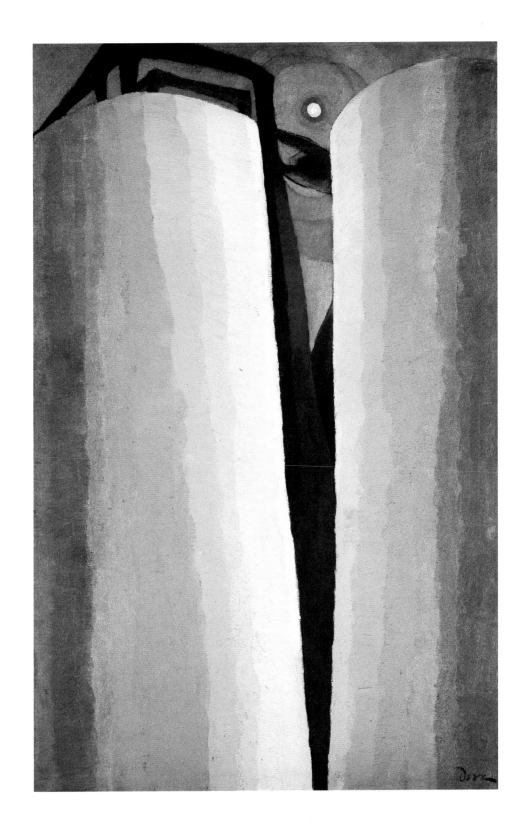

PLATE 14 | **GEORGIA O'KEEFFE,** *City Night*, 1926. Oil on canvas, 48 x 30 in. (121.9 x 76.2 cm).
The Minneapolis Institute of Arts. Gift of funds from the Regis Corporation, Mr. and Mrs. W. John Driscoll,
the Beim Foundation, the Larsen Fund, and by public subscription | BBL 529

PLATE 15 | **ARTHUR DOVE,** *Silver Tanks and Moon,* 1930. Oil and metallic paint on canvas, 28 ³/₁₆ x 18 ¹/₁₆ in.
(71.6 x 45.9 cm). Philadelphia Museum of Art. The Alfred Stieglitz Collection, 1949 | ALM 30.16; DBB PL. 49

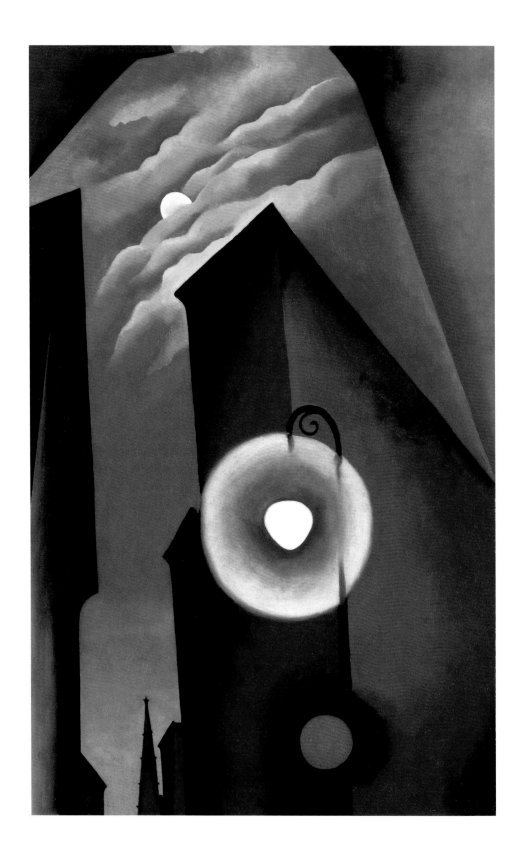

PLATE 16 | **GEORGIA O'KEEFFE,** *New York with Moon*, 1925. Oil on canvas, 48 x 30¼ in. (122 x 77 cm).

Carmen Thyssen-Bornemisza Collection, on loan at the Museo Thyssen-Bornemisza, Madrid | BBL 483

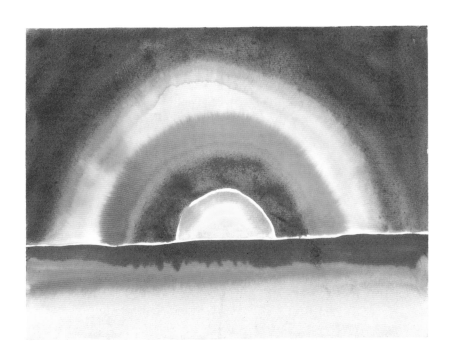

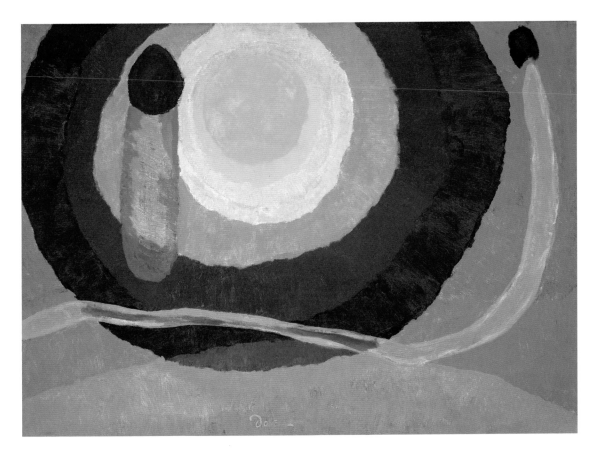

PLATE 17 | **GEORGIA O'KEEFFE,** *Sunrise*, 1916. Watercolor on paper, 8⅞ x 11⅞ in. (22.5 x 30.2 cm).
Collection of Barney A. Ebsworth | BBL 131

PLATE 18 | **ARTHUR DOVE,** *Sunrise I*, 1936. Tempera on canvas, 25 x 35 in. (63.5 x 88.9 cm).
Collection of Deborah and Ed Shein | ALM 36.14; DBB PL. 65

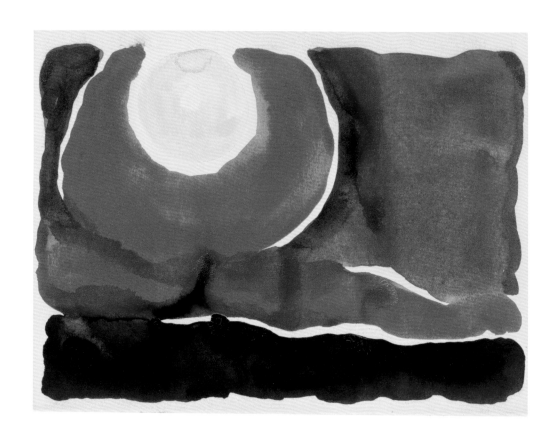

PLATE 19 | **GEORGIA O'KEEFFE,** *Evening Star No. VI*, 1917. Watercolor on paper, 8⁷⁄₈ x 12 in. (22.5 x 30.5 cm).

Georgia O'Keeffe Museum, Santa Fe, New Mexico. Gift of The Burnett Foundation | BBL 204

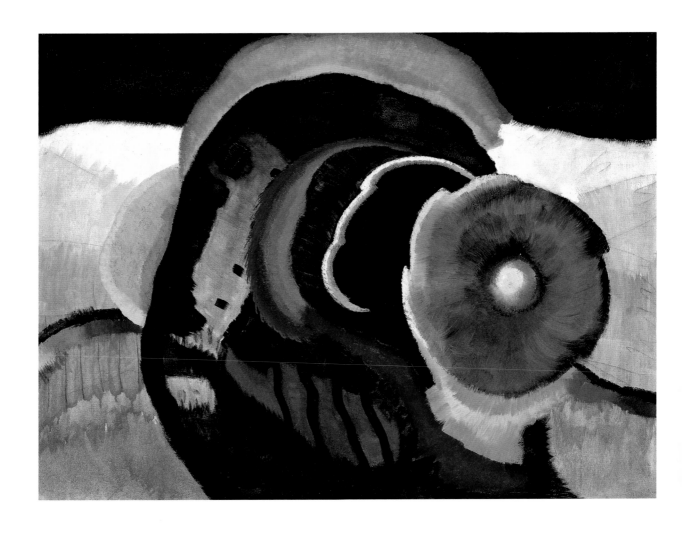

PLATE 20 | **ARTHUR DOVE,** *Alfie's Delight*, 1929. Oil on canvas, 22¾ x 31 in. (57.8 x 78.7 cm).

Herbert F. Johnson Museum of Art, Cornell University, Ithaca, New York.

Dr. and Mrs. Milton Lurie Kramer, Class of 1936, Collection; Bequest of Helen Kroll Kramer | ALM 29.1; DBB PL. 46

PLATE 21 | **ARTHUR DOVE,** *Sunrise*, 1924. Oil on panel, 18¼ x 20⅞ in. (46.4 x 53 cm).

Milwaukee Art Museum. Gift of Mrs. Edward R. Wehr | ALM 24.9; DBB PL. 22

PLATE 22 | **GEORGIA O'KEEFFE,** *Red & Orange Streak*, 1919. Oil on canvas, 27 x 23 in. (68.6 x 58.4 cm).
Philadelphia Museum of Art. Bequest of Georgia O'Keeffe for the Alfred Stieglitz Collection, 1987 | BBL 287

PLATE 23 | **GEORGIA O'KEEFFE,** *From the Lake, No. 1*, 1924. Oil on canvas, 36 x 30 in. (91.4 x 76.2 cm). Nathan Emory Coffin Collection of the Des Moines Art Center, Iowa. Purchased with funds from the Coffin Fine Arts Trust | BBL 470

PLATE 24 | **ARTHUR DOVE,** *Sea II*, 1925. Chiffon over metal with sand, 12½ x 20½ (31.8 x 52.1).

Collection of Barney A. Ebsworth | ALM 25.16; DBB PL. 30

PLATE 25 | **ARTHUR DOVE,** *Fog Horns*, 1929. Oil on canvas, 18 x 26 in. (45.7 x 66 cm).
Colorado Springs Fine Arts Center. Anonymous Gift, FA 1954.1 | ALM 29.6; DBB PL. 48

PLATE 26 | **GEORGIA O'KEEFFE,** *Wave, Night*, 1928. Oil on canvas, 30 x 36 in. (76.2 x 91.4 cm).
Addison Gallery of American Art, Phillips Academy, Andover, Massachusetts.
Purchased as the gift of Charles L. Stillman (PA 1922) | BBL 644

PLATE 27 | **GEORGIA O'KEEFFE,** *Dark Abstraction*, 1924. Oil on canvas, 24¾ x 21 in. (62.9 x 53.3 cm).
Saint Louis Art Museum. Gift of Charles E. and Mary Merrill | BBL 451

PLATE 28 | **ARTHUR DOVE,** *Thunderstorm*, 1921. Oil and metallic paint on canvas, 21½ x 18⅛ in. (54.6 x 46 cm).

Columbus Museum of Art, Ohio. Gift of Ferdinand Howald | ALM 21.5; DBB PL. 26

PLATE 29 | **ARTHUR DOVE,** *Chinese Music*, 1923. Oil on panel, 21^{11}/$_{16}$ x 18^{1}/$_{8}$ in. (55.1 x 46 cm).

Philadelphia Museum of Art. The Alfred Stieglitz Collection, 1949 | ALM 23.3

PLATE 30 | **GEORGIA O'KEEFFE,** *Lake George with Crows*, 1921. Oil on canvas, 28³/₈ x 24⁷/₈ in. (72 x 63.2 cm).

National Gallery of Canada, Ottawa. Gift of The Georgia O'Keeffe Foundation, Abiquiu, New Mexico, 1995 | BBL 358

PLATE 32 | **GEORGIA O'KEEFFE,** *The Chestnut Grey*, 1924. Oil on canvas, 36 x 30⅛ in. (91.4 x 76.5 cm).

Curtis Galleries, Minneapolis | BBL 473

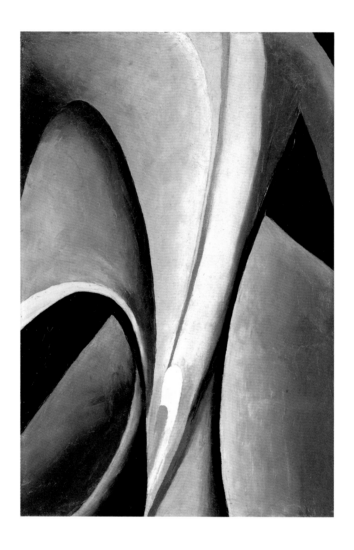

PLATE 33 | **GEORGIA O'KEEFFE,** *Abstraction*, 1919. Oil on canvas, 10⅛ x 7¹/₁₆ in. (25.7 x 17.9 cm).

Newark Museum. Gift of Henry Ploch, 2000 | BBL 286

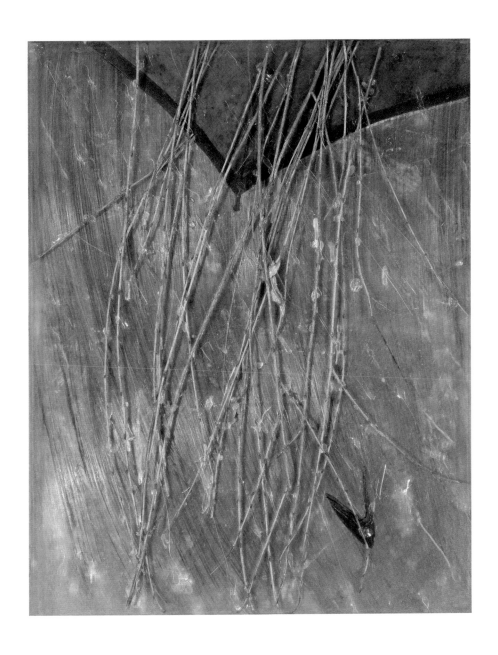

PLATE 34 | ARTHUR DOVE, *Rain*, 1924. Assemblage of twigs and rubber cement on metal and glass, shown without frame, 19½ x 15⅝ in. (49.5 x 39.7 cm). National Gallery of Art, Washington, D.C. Avalon Fund | ALM 24.6; DBB PL. 27

PLATE 35 | **GEORGIA O'KEEFFE,** *The Lawrence Tree*, 1929. Oil on canvas, 31⅛ x 39¼ in. (79.1 x 99.7 cm).

Wadsworth Atheneum Museum of Art, Hartford, Connecticut.

The Ella Gallup Sumner and Mary Catlin Sumner Collection Fund | BBL 687

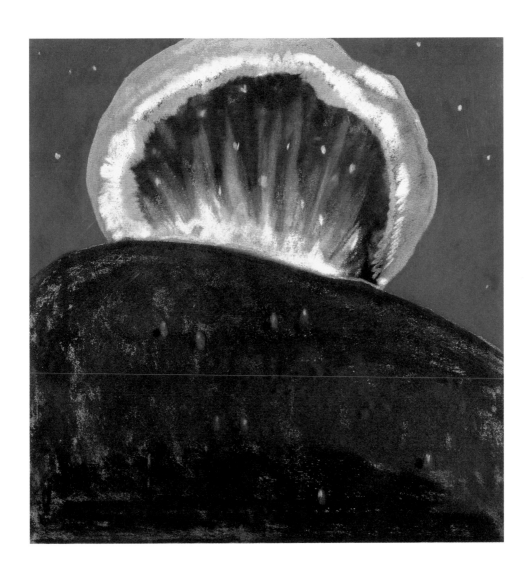

PLATE 36 | **ARTHUR DOVE,** *March, April*, 1929. Pastel on canvas, 20 x 20 in. (50.8 x 50.8 cm).

Private collection | ALM 29.9

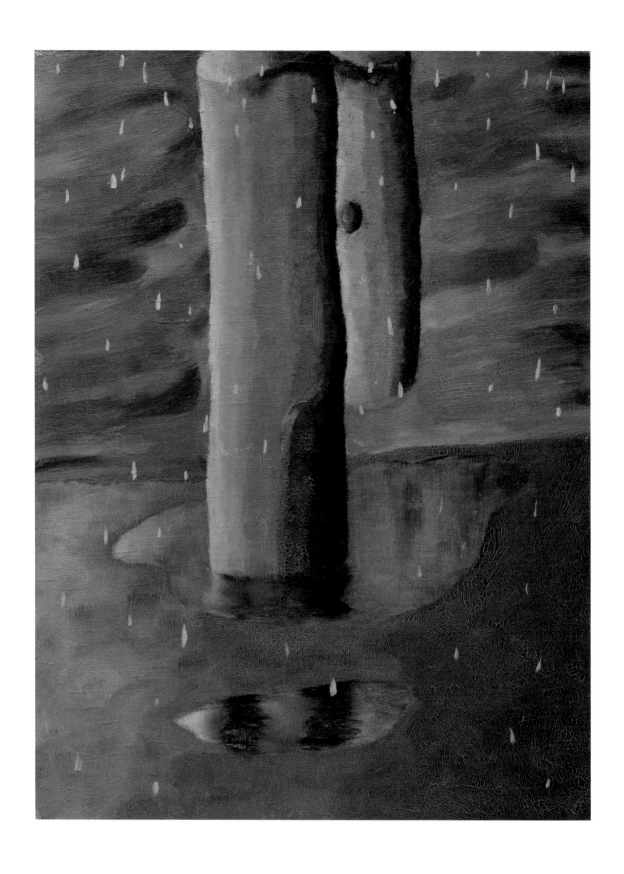

PLATE 37 | **ARTHUR DOVE,** *Wednesday, Snow*, 1932. Oil on canvas, 24 x 18 in. (61 x 45.7 cm).

William H. and Saundra B. Lane Collection. Courtesy Museum of Fine Arts, Boston | ALM 32.19

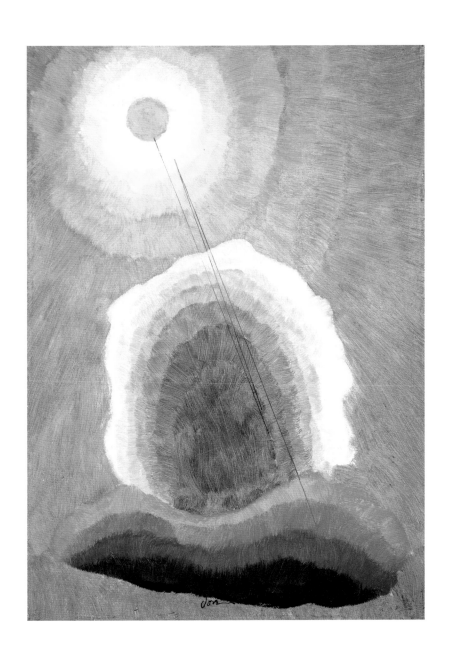

PLATE 38 | **ARTHUR DOVE,** *Golden Sun*, 1937. Oil on canvas, 13¾ x 9¾ in. (34.9 x 24.8 cm).

Collection of Pitt and Barbara Hyde | ALM 37.7; DBB PL. 68

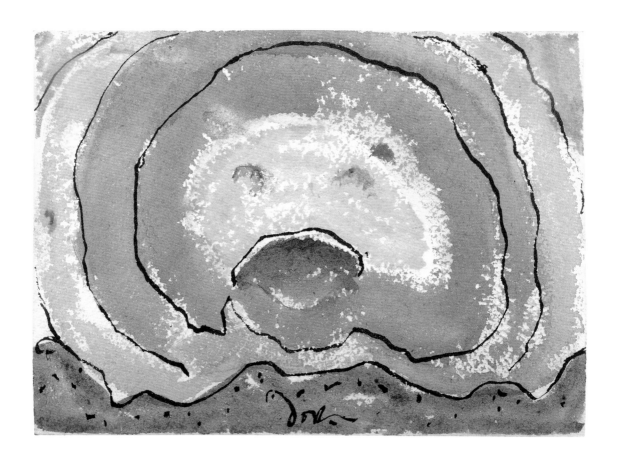

PLATE 39 | **ARTHUR DOVE,** *Happy Clam Shell*, 1938. Watercolor on paper, 5 x 7 in. (12.7 x 17.8 cm).
Private collection, Courtesy Alexandre Gallery, New York

PLATE 40 | **GEORGIA O'KEEFFE,** *Slightly Open Clam Shell*, 1926. Pastel on artistboard, 18½ x 13 in. (47 x 33 cm).
Wadsworth Atheneum Museum of Art, Hartford, Connecticut.
The Douglas Tracy Smith and Dorothy Potter Smith Fund | BBL 537

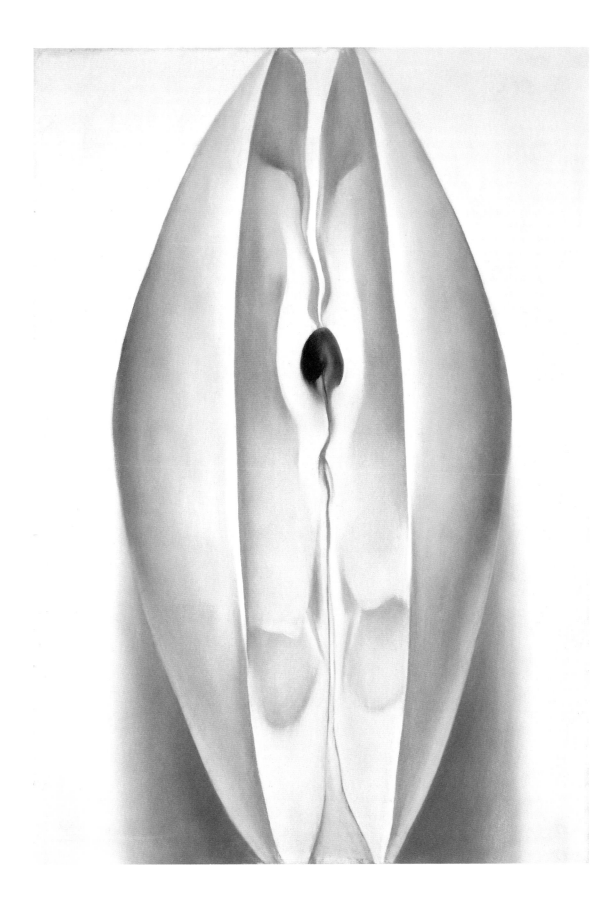

PLATE 41 | **ARTHUR DOVE,** *Pond in Sunlight*, 1935. Watercolor on paper, 5⅛ x 7⅛ in. (13 x 18.1 cm).

The Metropolitan Museum of Art, New York. Alfred Stieglitz Collection, 1949 (49.70.80)

PLATE 42 | **ARTHUR DOVE,** *Sun, Centerport*, 1941. Watercolor on paper, 4³⁄₈ x 6 in. (11.1 x 15.2 cm).

Private collection, New York

PLATE 43 | **ARTHUR DOVE,** *Untitled [Mountain and Sun]*, undated. Watercolor on paper, 5 x 7 in. (12.7 x 17.8 cm).
Georgia O'Keeffe Museum, Santa Fe, New Mexico. Gift of Mr. and Mrs. Eugene V. Thaw

PLATE 44 | **GEORGIA O'KEEFFE,** *Evening*, 1916. Watercolor on paper, 8⅞ x 12 in. (22.5 x 30.5 cm).

Georgia O'Keeffe Museum, Santa Fe, New Mexico.

Gift of The Burnett Foundation and The Georgia O'Keeffe Foundation | BBL 104

PLATE 45 | **ARTHUR DOVE,** *Coal Carrier*, 1930. Gouache on paper, 3¾ x 4½ in. (9.5 x 11.4 cm).
The Estate of Arthur Dove

PLATE 46 | **ARTHUR DOVE,** *Study for Fall Brook Freight Car*, 1938. Watercolor on paper, 5 x 7 in. (12.7 x 17.8 cm).

Collection of Ellsworth Kelly

PLATE 47 | **ARTHUR DOVE,** *Tree*, 1935. Watercolor, tempera, brush, and ink on paper, 5 x 7 in. (12.7 x 17.8 cm). The Metropolitan Museum of Art, New York. Alfred Stieglitz Collection, 1949 (49.70.96)

PLATE 48 | **ARTHUR DOVE,** *Lake Ontario*, 1937. Watercolor on paper, 5 x 7 in. (12.7 x 17.8 cm). Private collection

PLATE 49 | **GEORGIA O'KEEFFE,** *Train at Night in the Desert*, 1916. Watercolor and pencil on paper, 11⅞ x 8⅞ in. (30.2 x 22.5 cm). The Museum of Modern Art, New York. Acquired with matching funds from the Committee on Drawings and the National Endowment for the Arts, 1979 | BBL 129

PLATE 50 | ARTHUR DOVE, *War*, 1939. Gouache and aluminum leaf on paper, 7 x 5 in. (17.8 x 12.7 cm).
The Museum of Modern Art, New York. Given anonymously (by exchange), 1980

PLATE 51 | ARTHUR DOVE, *Untitled [8-15-43]*, 1943. Gouache on paper, 3 x 4 in. (7.6 x 10.2 cm). The Estate of Arthur Dove

PLATE 52 | ARTHUR DOVE, *Untitled [8-14-43]*, 1943. Gouache on paper, 3 x 4 in. (7.6 x 10.2 cm). The Estate of Arthur Dove

PLATE 53 | ARTHUR DOVE, *Untitled [8-16-43]*, 1943. Gouache on paper, 3 x 4 in. (7.6 x 10.2 cm). The Estate of Arthur Dove

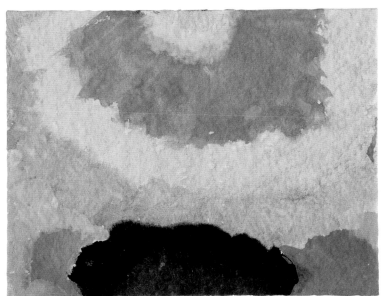

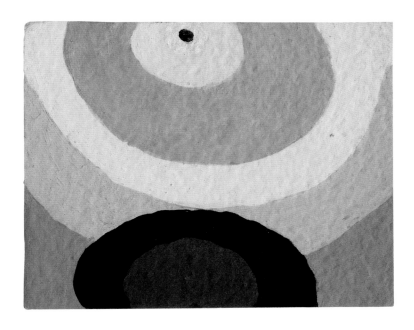

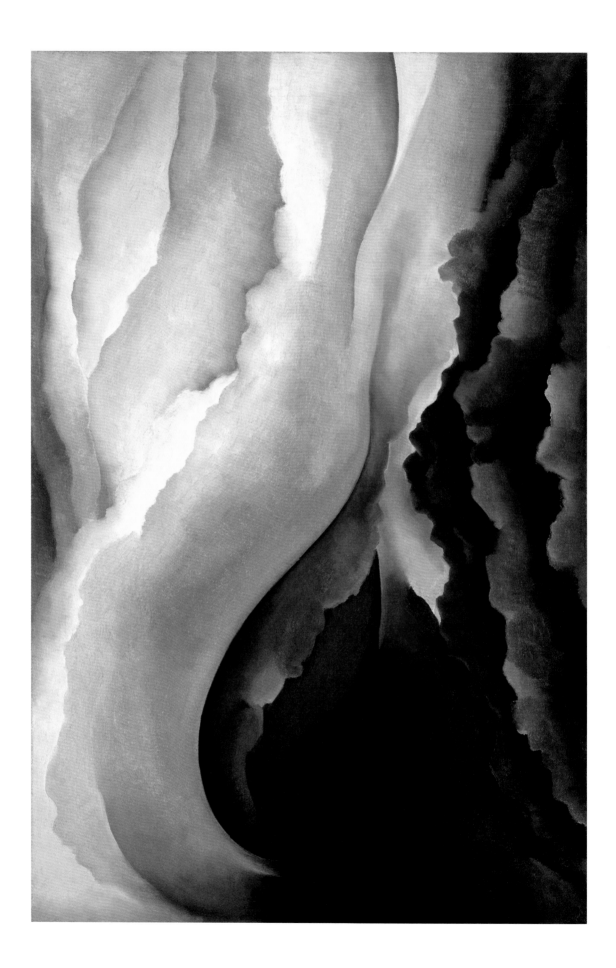

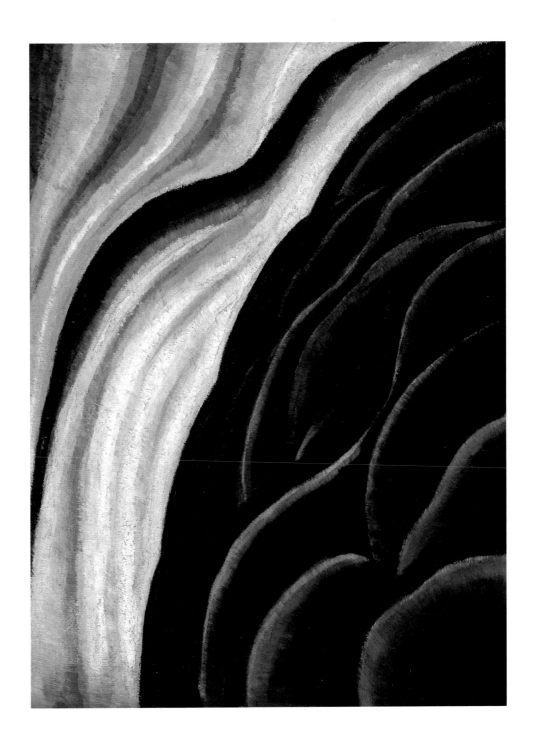

PLATE 54 | GEORGIA O'KEEFFE, *Dark Iris No. 2*, 1927. Oil on canvas, 32 x 21 in. (81.3 x 53.3 cm).
Collection of Deborah and Ed Shein | BBL 603

PLATE 55 | ARTHUR DOVE, *Sea Gull Motive (Sea Thunder or The Wave)*, 1928. Oil on panel, 26¼ x 20½ in. (66.7 x 52.1 cm).
Fine Arts Museums of San Francisco. Museum purchase, Richard B. Gump Trust Fund, Museum Society Auxiliary,
Museum Acquisition Fund, Peter and Kirsten Bedford, Mrs. George Hopper Fitch, Art Trust Fund,
and by exchange of Foundation objects | ALM 26.15

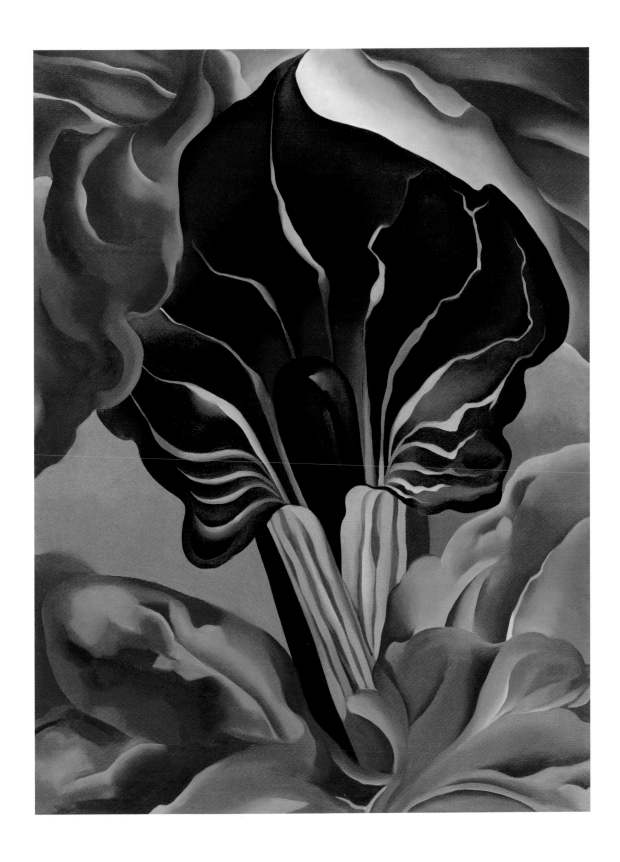

PLATE 56 | **GEORGIA O'KEEFFE,** *Jack-in-Pulpit — No. 2,* 1930. Oil on canvas, 40 x 30 in. (101.6 x 76.2 cm).

National Gallery of Art, Washington, D.C. Alfred Stieglitz Collection, Bequest of Georgia O'Keeffe | BBL 716

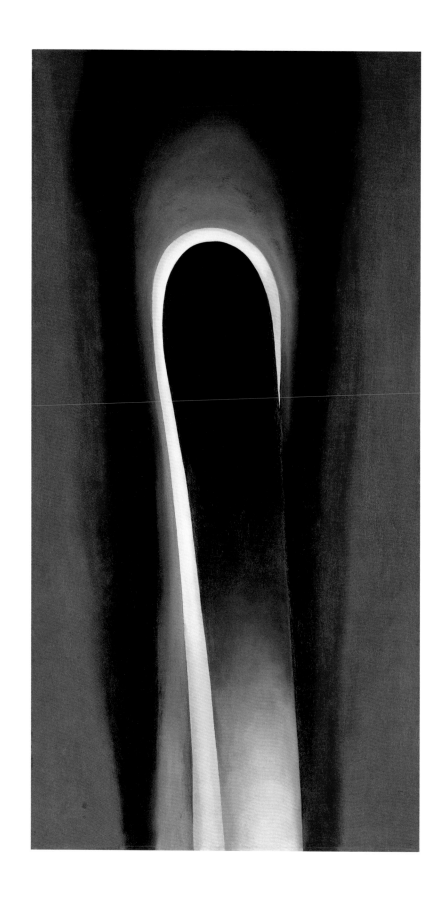

PLATE 57 | **GEORGIA O'KEEFFE,** *Jack-in-the-Pulpit No. VI*, 1930. Oil on canvas, 36 x 18 in. (91.4 x 45.7 cm).

National Gallery of Art, Washington, D.C. Alfred Stieglitz Collection, Bequest of Georgia O'Keeffe | BBL 720

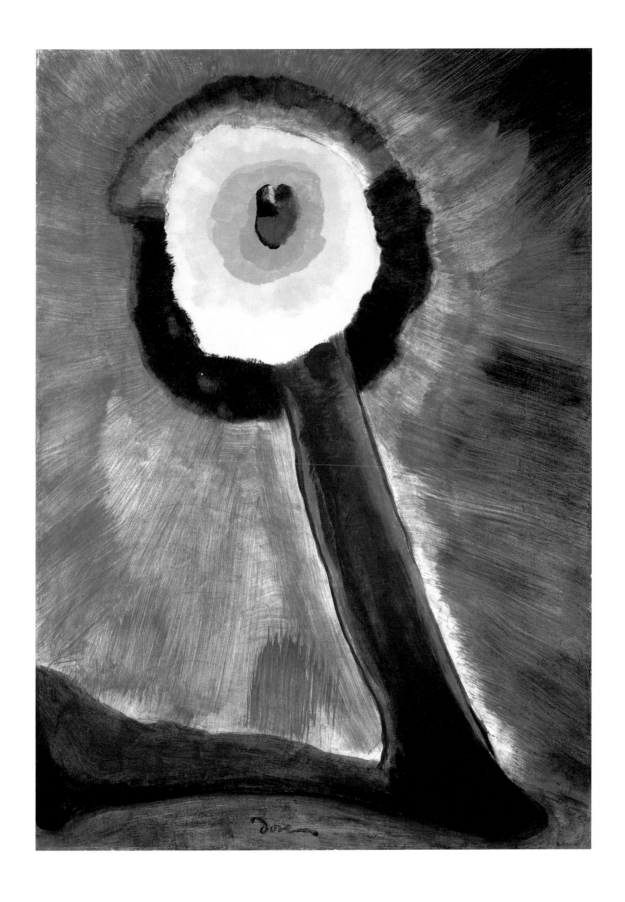

PLATE 58 | **ARTHUR DOVE,** *Moon*, 1935. Oil on canvas, 35 x 25 in. (88.9 x 63.5 cm).

National Gallery of Art, Washington, D.C. Collection of Barney A. Ebsworth | ALM 36.8; DBB PL. 62

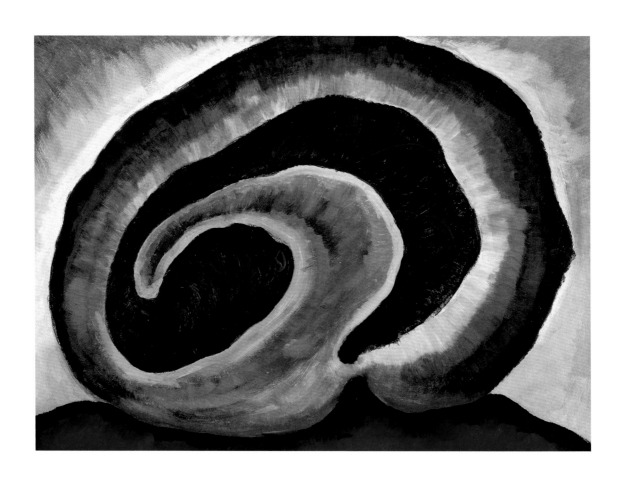

PLATE 59 | **ARTHUR DOVE,** *Willow Tree*, 1937. Oil on canvas, 20 x 28 in. (50.8 x 71.1 cm).

Norton Museum of Art, West Palm Beach, Florida. Bequest of R. H. Norton | ALM 37.16

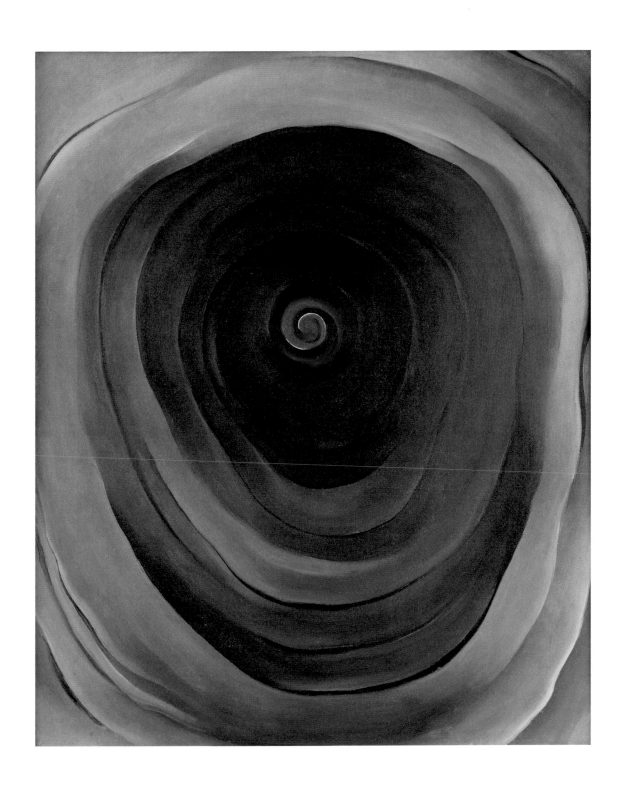

PLATE 60 | **GEORGIA O'KEEFFE,** *A Piece of Wood II*, 1942. Oil on canvas, 24 x 20 in. (61 x 50.8 cm).

The Shey Collection. Through the Harn Museum, Gainesville, Florida | BBL 1031

Selected Bibliography

Balken, Debra Bricker. *After Many Springs: Regionalism, Modernism, and the Midwest*. Exh. cat. Des Moines, Iowa: Des Moines Art Center; New Haven, Conn.: Yale University Press, 2009.

———. *Arthur Dove: A Retrospective*. Exh. cat. Andover, Mass.: Addison Gallery of American Art; Cambridge, Mass.: MIT Press, in association with the Phillips Collection, Washington, D.C., 1997.

———. *Debating American Modernism: Stieglitz, Duchamp, and the New York Avant-Garde*. Exh. cat. New York: American Federation of Arts and D.A.P., 2003.

Bell, Clive. *Art*. London: Chatto and Windus, 1928.

Brennan, Marcia. *Painting Gender, Constructing Theory: The Alfred Stieglitz Circle and American Formalist Aesthetics*. Cambridge, Mass.: MIT Press, 2001.

Bulliet, C. J. *Apples & Madonnas: Emotional Expression in Modern Art*. Chicago: Pascal Covici, 1927.

Cheney, Sheldon. *A Primer of Modern Art*. New York: Boni & Liveright, 1924.

Cowart, Jack, and Juan Hamilton. *Georgia O'Keeffe, Art and Letters*. Washington, D.C.: National Gallery of Art; Boston: New York Graphic Society Books, 1987.

Craven, Thomas. "American Men of Art." *Scribner's Magazine*, Nov. 1932, 260–72.

———. "Art and the Camera." *Nation*, 16 Apr. 1924, 456–57.

———. *Modern Art: The Men, the Movements, the Meaning*. New York: Simon & Schuster, 1934.

Duchamp, Marcel. "The Iconoclastic Opinions of M. Marcel Duchamps [sic] Concerning Art and America." *Current Opinion* 59 (Nov. 1915): 346–47.

Eddy, Arthur Jerome. *Cubists and Post-Impressionism*. 1914. Reprint, Chicago: A. C. McClurg and Company, 1919.

Eldredge, Charles C. *Georgia O'Keeffe: American and Modern*. Exh. cat. New Haven, Conn.: Yale University Press in association with InterCultura, Fort Worth, Tex., The Georgia O'Keeffe Foundation, Abiquiu, N. Mex., and the South Bank Center, London, 1993.

Fine, Ruth E., et al. *The Book Room: Georgia O'Keeffe's Library in Abiquiu*. Exh. cat. New York: The Georgia O'Keeffe Foundation and the Grolier Club, 1997.

The Forum Exhibition of Modern American Painters: March 13th to March 25th, 1916. Exh. cat. New York: Anderson Galleries, 1916.

Frank, Waldo, ed. *America and Alfred Stieglitz: A Collective Portrait*. New York: The Literary Guild, 1934.

———. *Our America*. New York: Boni & Liveright, 1919.

"Georgia O'Keeffe — C. Duncan — Réné Lafferty." *Camera Work* 48 (Oct. 1916): 12.

Giboire, Clive, ed. *Lovingly, Georgia: The Complete Correspondence of Georgia O'Keeffe and Anita Pollitzer*. Introduction by Benita Eisler. New York: Simon & Schuster, 1990.

Green, Nancy E., and Jessie Poesch. *Arthur Wesley Dow and American Arts & Crafts*. Exh. cat. New York: The American Federation of Arts in association with Harry N. Abrams, 1999.

Greenberg, Clement. *The Collected Essays and Criticism*. Vol. 2: *Arrogant Purpose, 1945–1949*. Edited by John O'Brian. Chicago: University of Chicago Press, 1986.

Greenough, Sarah, et al. *Modern Art and America: Alfred Stieglitz and His New York Galleries*. Exh. cat. Washington, D.C.: National Gallery of Art, 2001.

Hartley, Marsden. *Adventures in the Arts: Informal Chapters on Painters, Vaudeville, and Poets*. New York: Boni & Liveright, 1921.

Homer, William Innes. "Abiquiu is a long way for you to come." *American Art* 20, no. 3 (Fall 2006): 8–13.

Kandinsky, Wassily. "Extracts from 'The Spiritual in Art.'" *Camera Work* 39 (Jul. 1912): 34.

Kootz, Samuel M. *Modern American Painters*. New York: Brewer & Warren, 1930.

Kuh, Katharine. *The Artist's Voice: Talks with Seventeen Artists*. New York: Harper & Row, 1962.

Leigh, Ted, ed. *Material Witness: The Selected Letters of Fairfield Porter*. Ann Arbor: University of Michigan Press, 2005.

Looney, Ralph. "Georgia O'Keeffe." *Atlantic Monthly*, Apr. 1965, 106–10.

Lynes, Barbara Buhler. *Georgia O'Keeffe: Catalogue Raisonné*. 2 vols. New Haven, Conn.: Yale University Press, 1999.

———. *O'Keeffe, Stieglitz and the Critics, 1916–1929*. Ann Arbor: UMI Research Press, 1989.

Matthias, Blanche C. "Georgia O'Keeffe and the Intimate Gallery: Stieglitz Showing Seven Americans." *Chicago Evening Post Magazine of the Art World*, 2 Mar. 1926, 14.

McBride, Henry. *The Flow of Art: Essays and Criticism of Henry McBride*. Edited by Daniel Catton Rich. New Haven, Conn.: Yale University Press, 1997.

McCausland, Elizabeth. "To Be or Not to Be Precious: Georgia O'Keeffe's Flower Paintings." *Springfield Daily Republican*, 28 Apr. 1935.

Morgan, Ann Lee. *Arthur Dove: Life and Work, with a Catalogue Raisonné*. Newark: University of Delaware Press, 1984.

———, ed. *Dear Stieglitz, Dear Dove*. Newark: University of Delaware Press; London: Associated University Presses, 1988.

Rosenberg, Harold. *Art & Other Serious Matters*. Chicago: University of Chicago Press, 1985.

Rosenfeld, Paul. "American Painting." *Dial* 71 (Dec. 1921): 649–70.

———. *Port of New York: Essays on Fourteen American Moderns*. New York: Harcourt, Brace, 1924.

Seligmann, Herbert. *Alfred Stieglitz Talking: Notes on Some of His Conversations, 1925–1931*. New Haven, Conn.: Yale University Library, 1966.

Simpson, Marc. "Arthur G. Dove's *Sea Gull Motive*." *Triptych* (membership magazine for the M. H. de Young Memorial Museum, San Francisco) 53 (Nov./Dec. 1990): 18–20.

Webster, H. Effa. "Artist Dove Paints Rhythms of Color." *Chicago Examiner*, 15 Mar. 1912, 12.

Wilson, Edmund. "The Stieglitz Exhibition." *New Republic*, 18 Mar. 1925, 97–98.

Wright, Willard Huntington. *Modern Painting: Its Tendency and Meanings*. New York: John Lane, 1915.

Zayas, Marius de. "The Evolution of Form, Introduction." *Camera Work* 41 (Jan. 1913): 44–48.

———. *How, When, and Why Modern Art Came to New York*. Edited by Francis M. Naumann. Cambridge, Mass.: MIT Press, 1996.

———. "The Sun Has Set." *Camera Work* 39 (Jul. 1912): 17–21.

———. Untitled statement. *291* 5–6 (Jul.–Aug. 1915): n.p.

Zayas, Marius de, and Paul B. Haviland. *A Study of the Modern Evolution of Plastic Expression*. New York: 291, 1913.

Index

Photography Credits